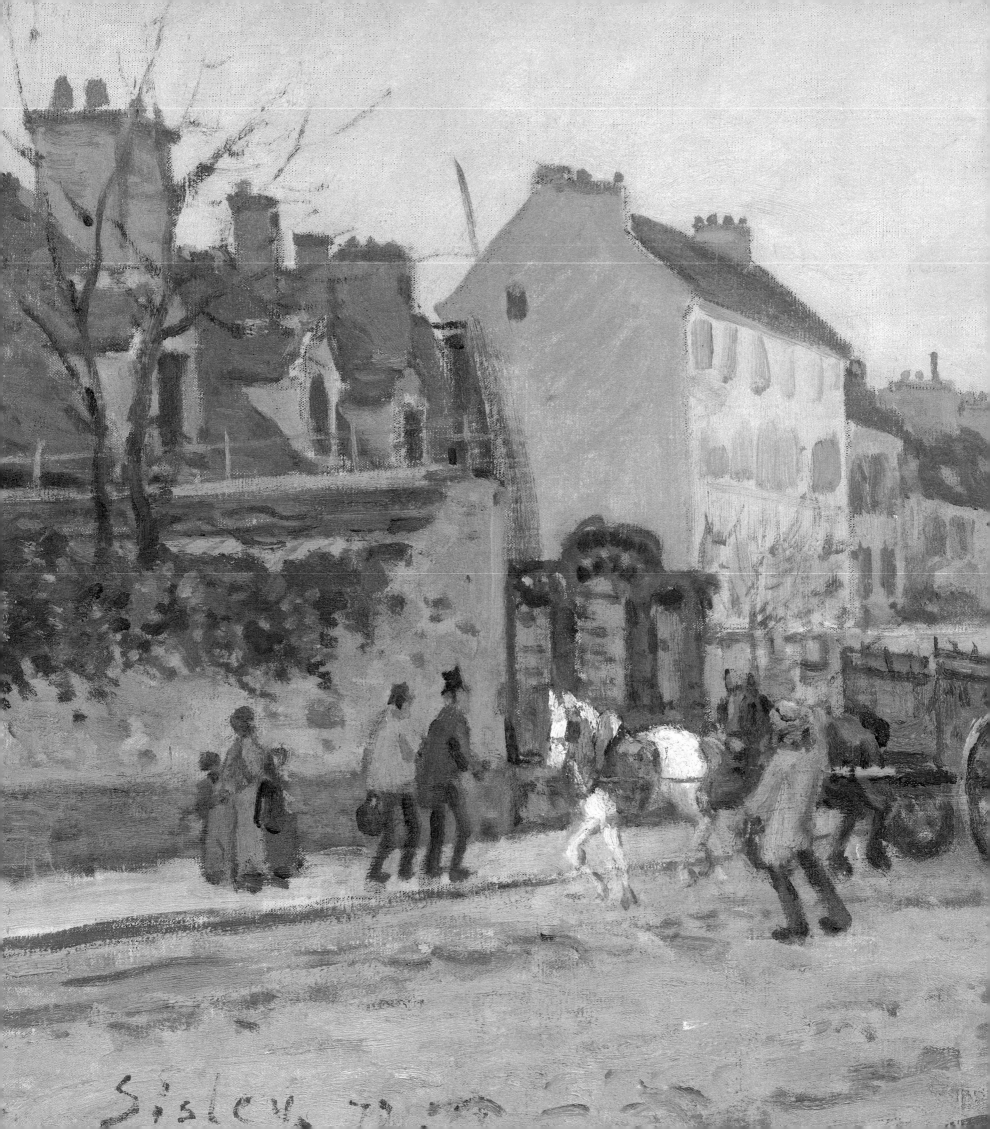

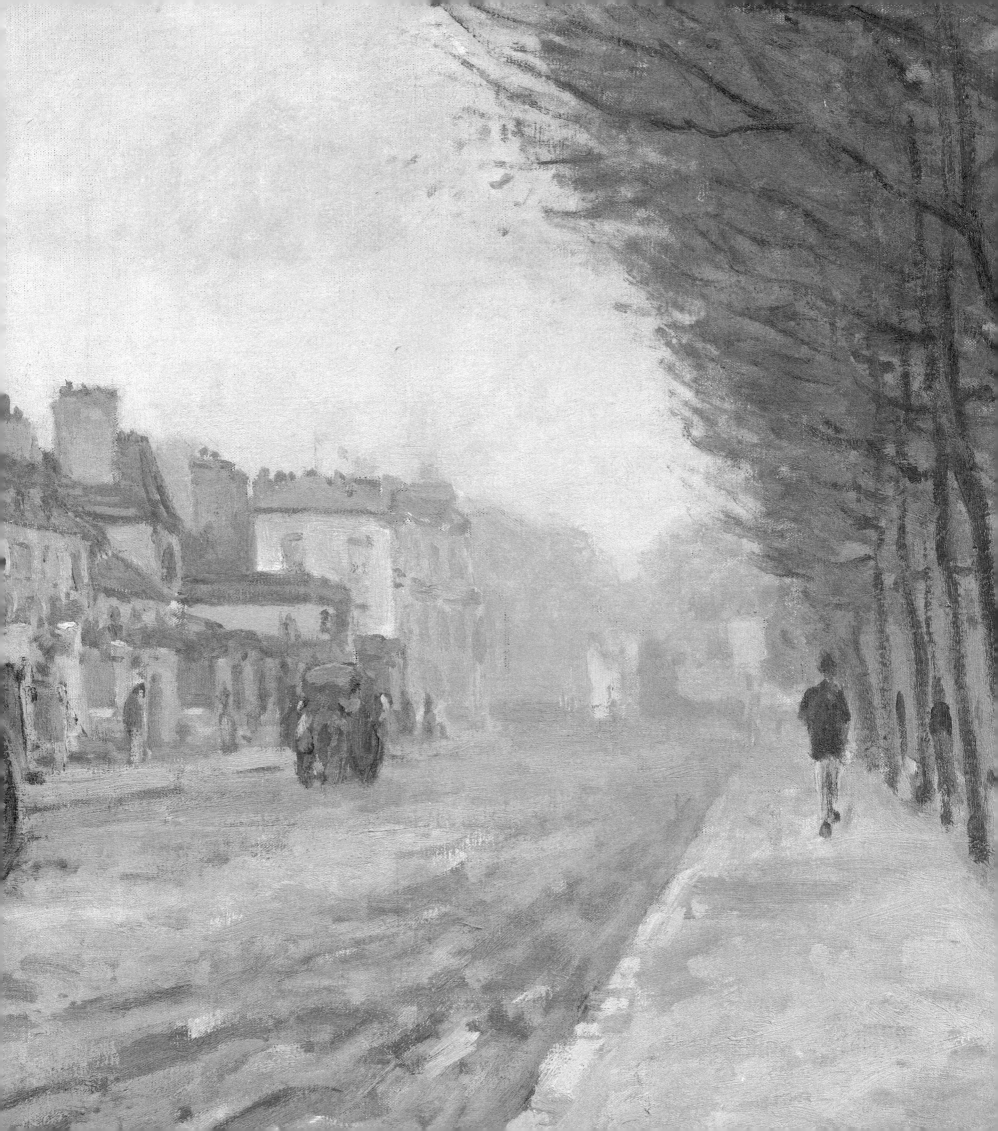

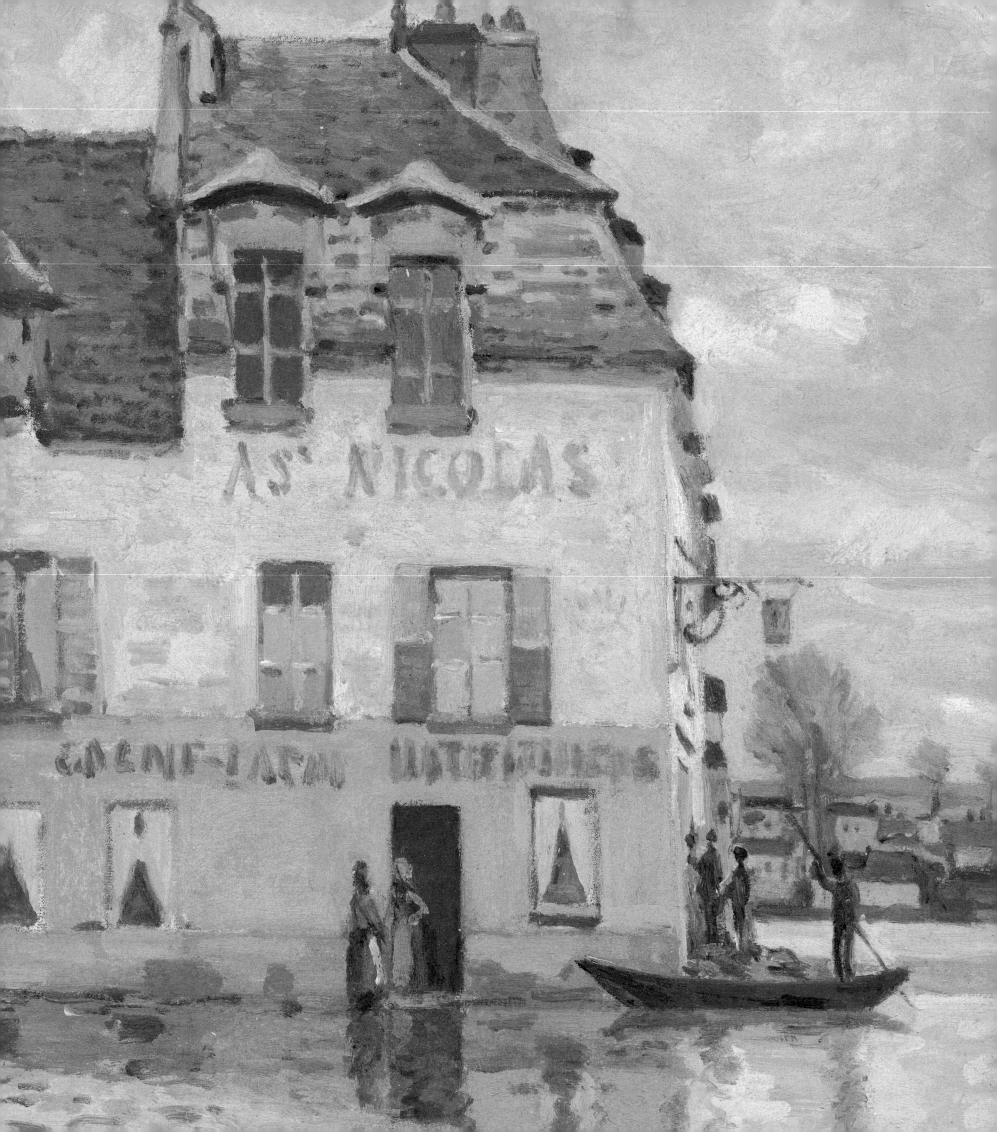

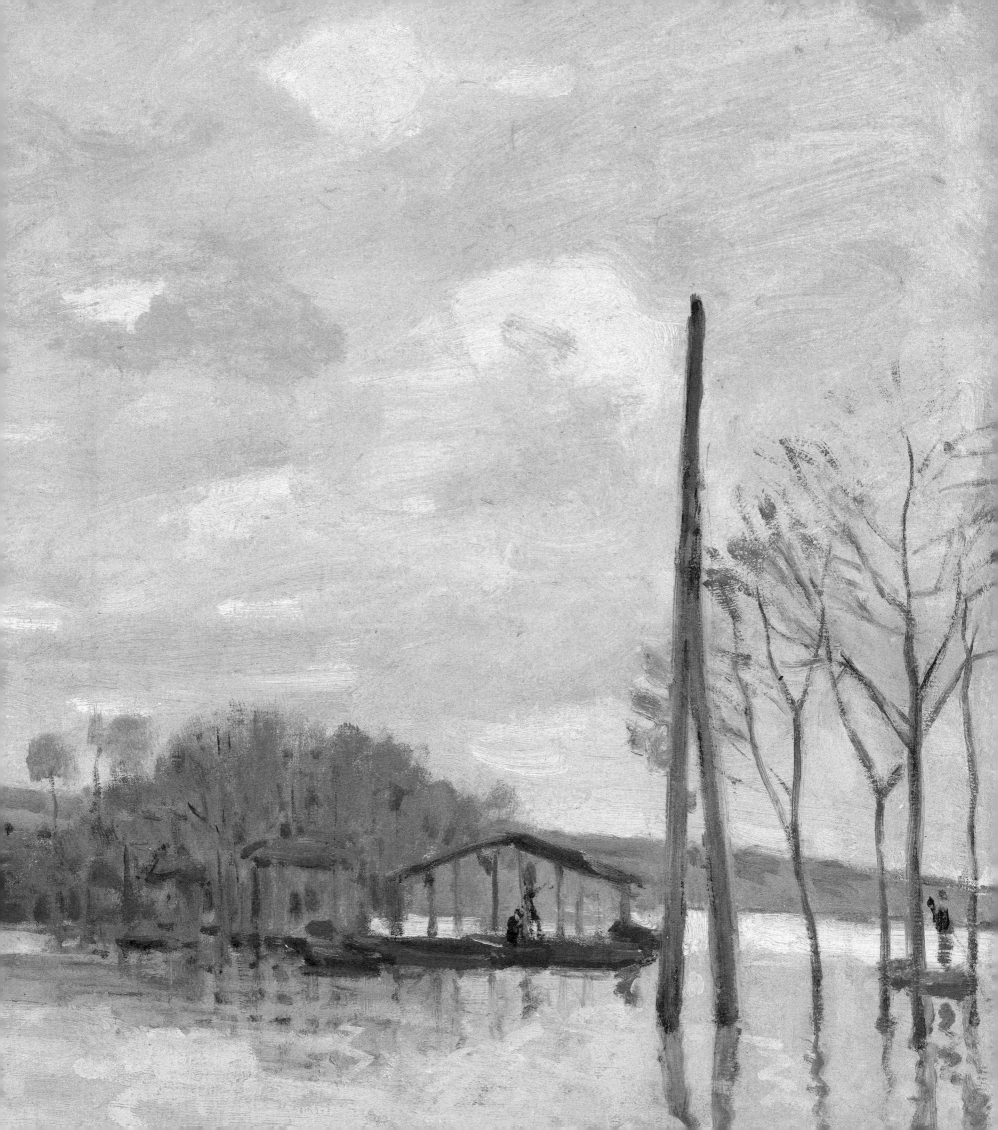

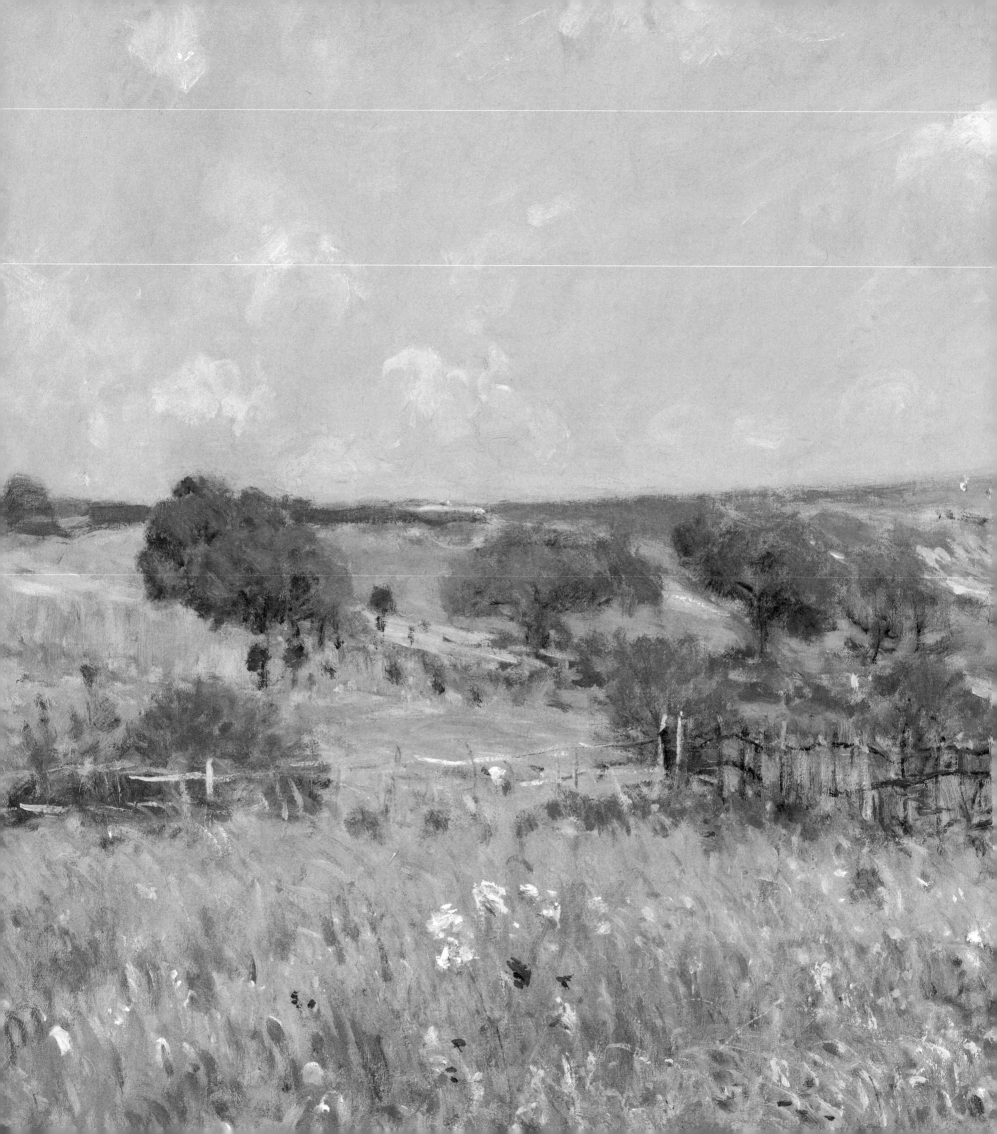

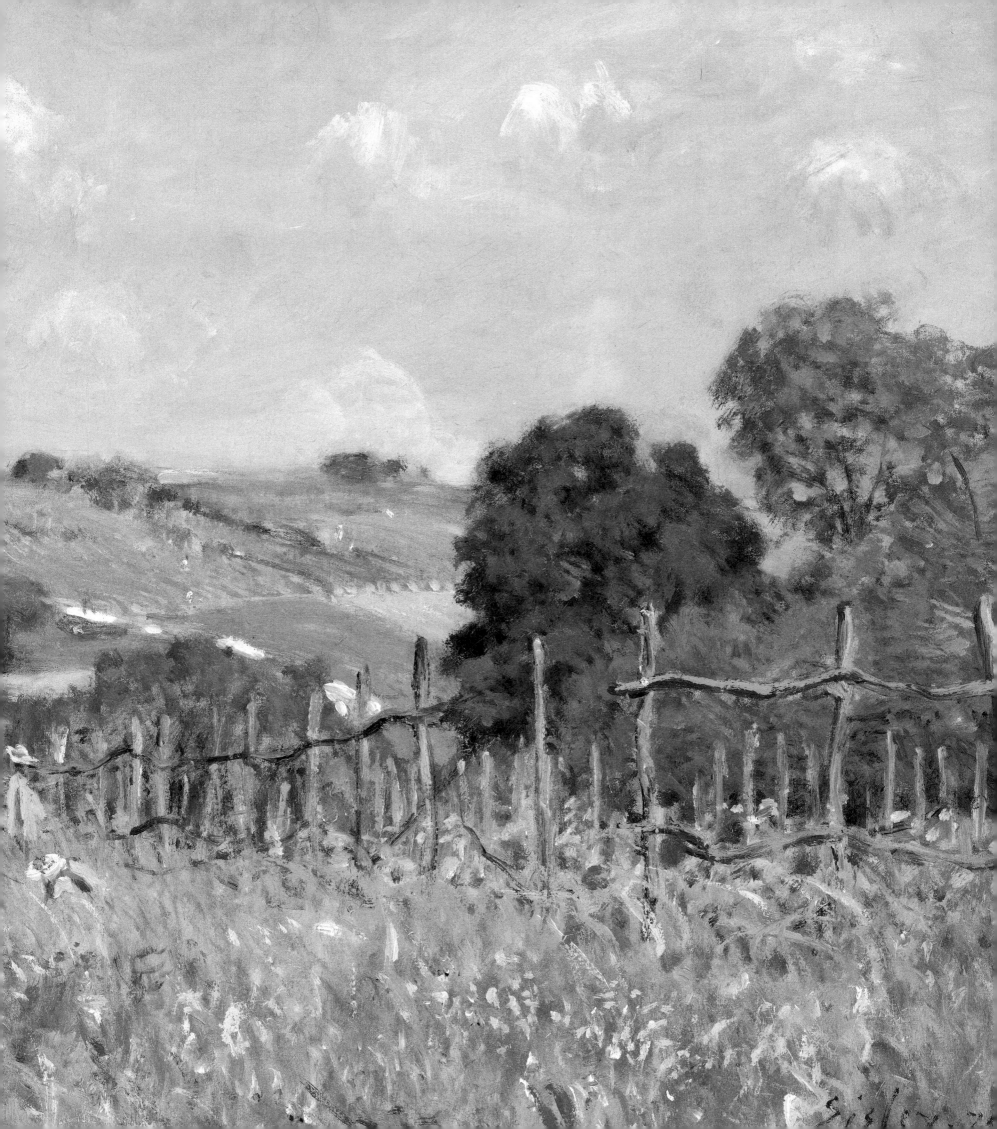

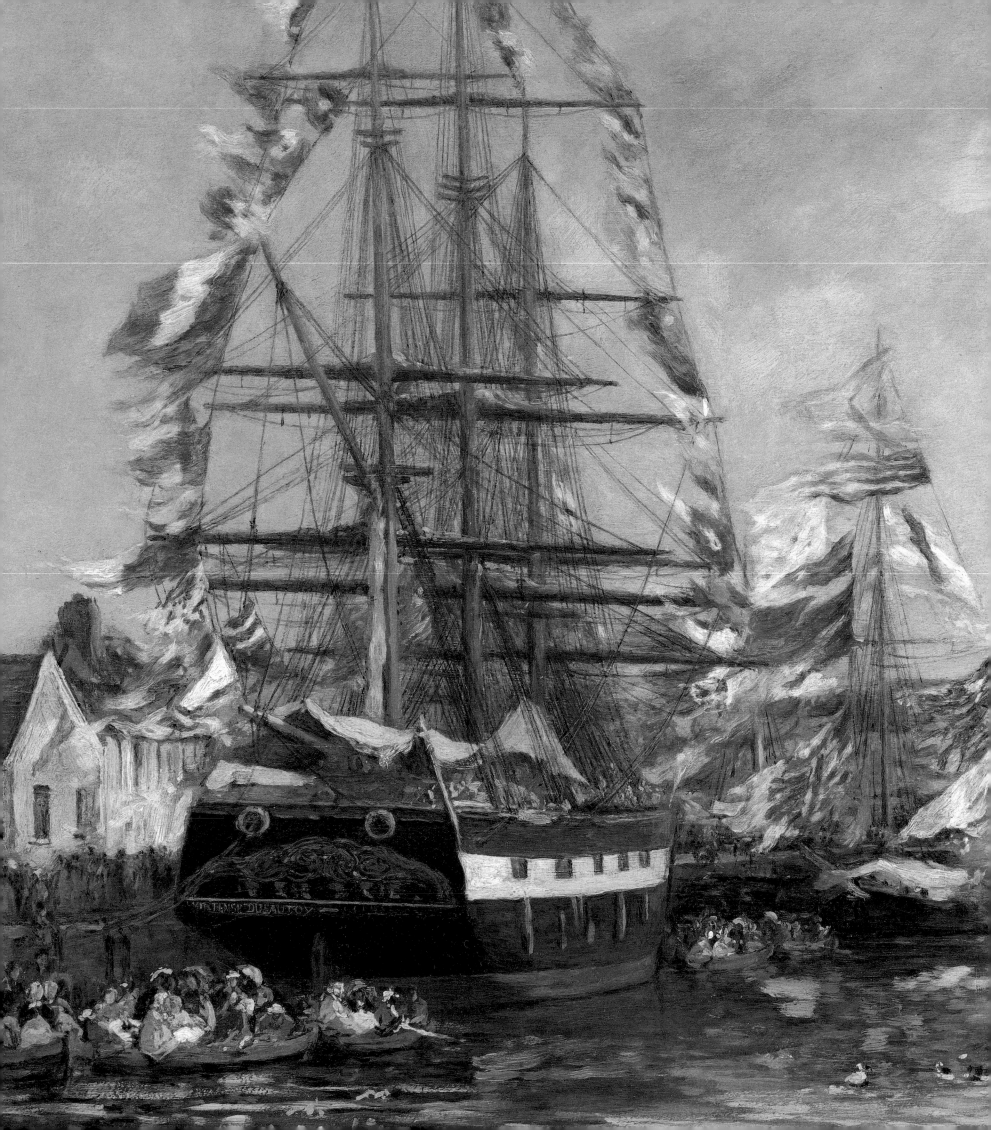

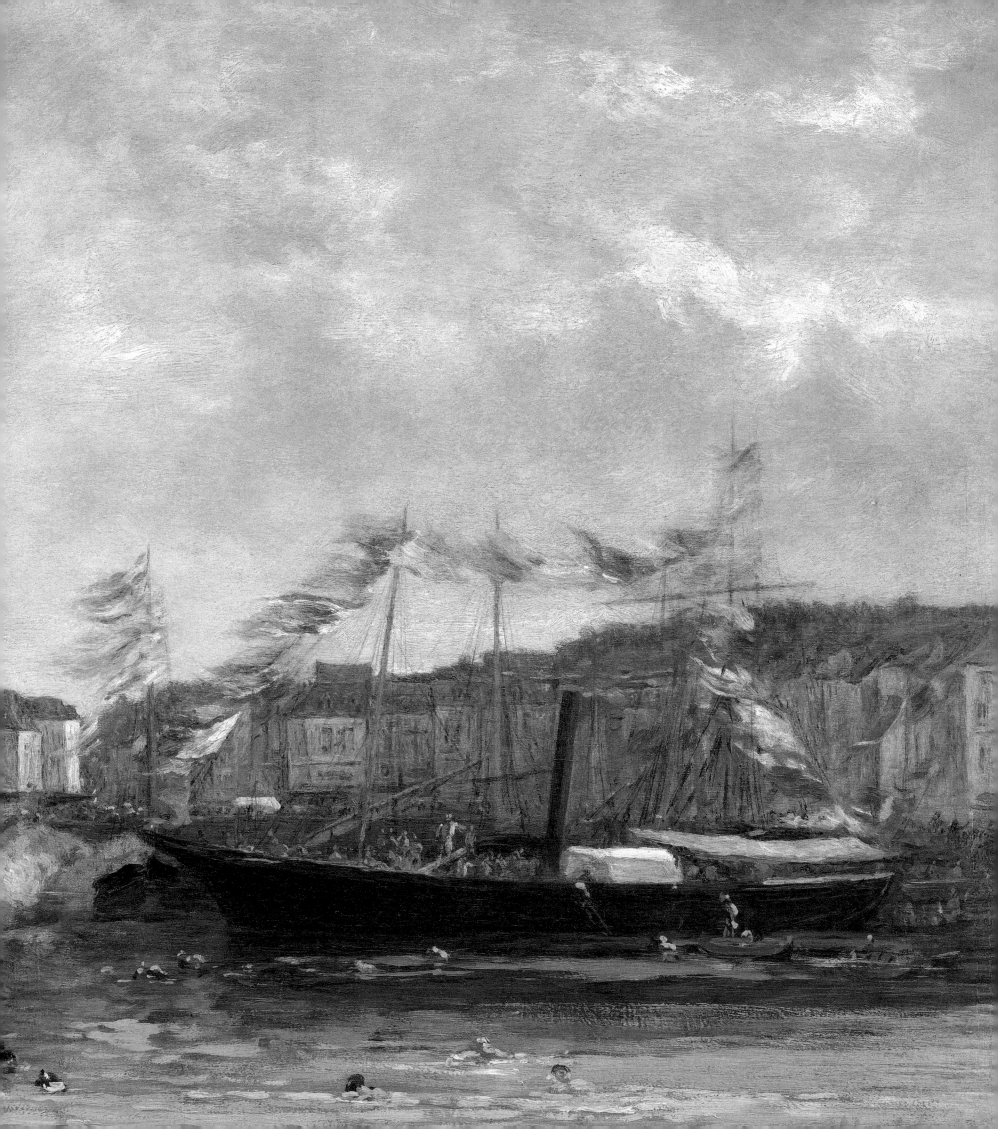

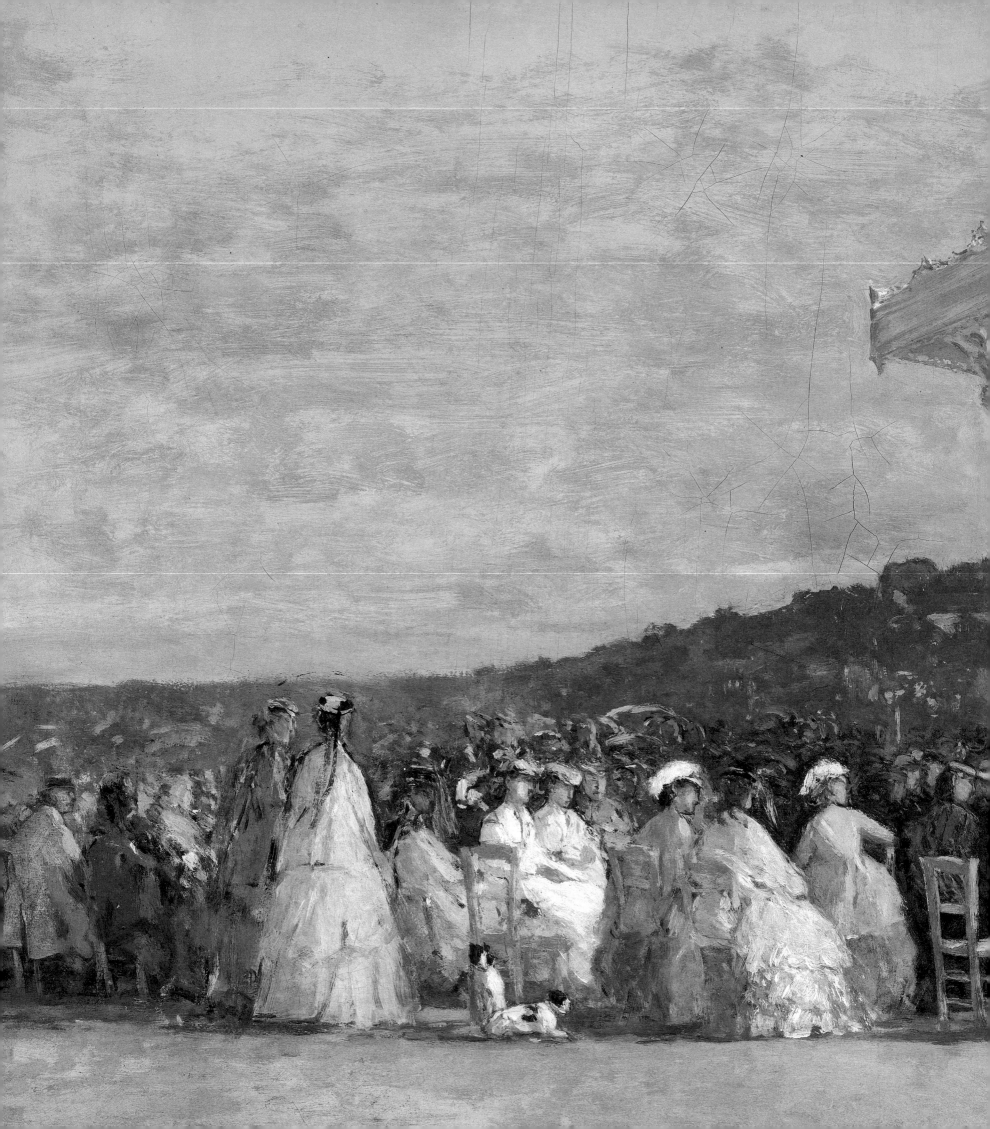

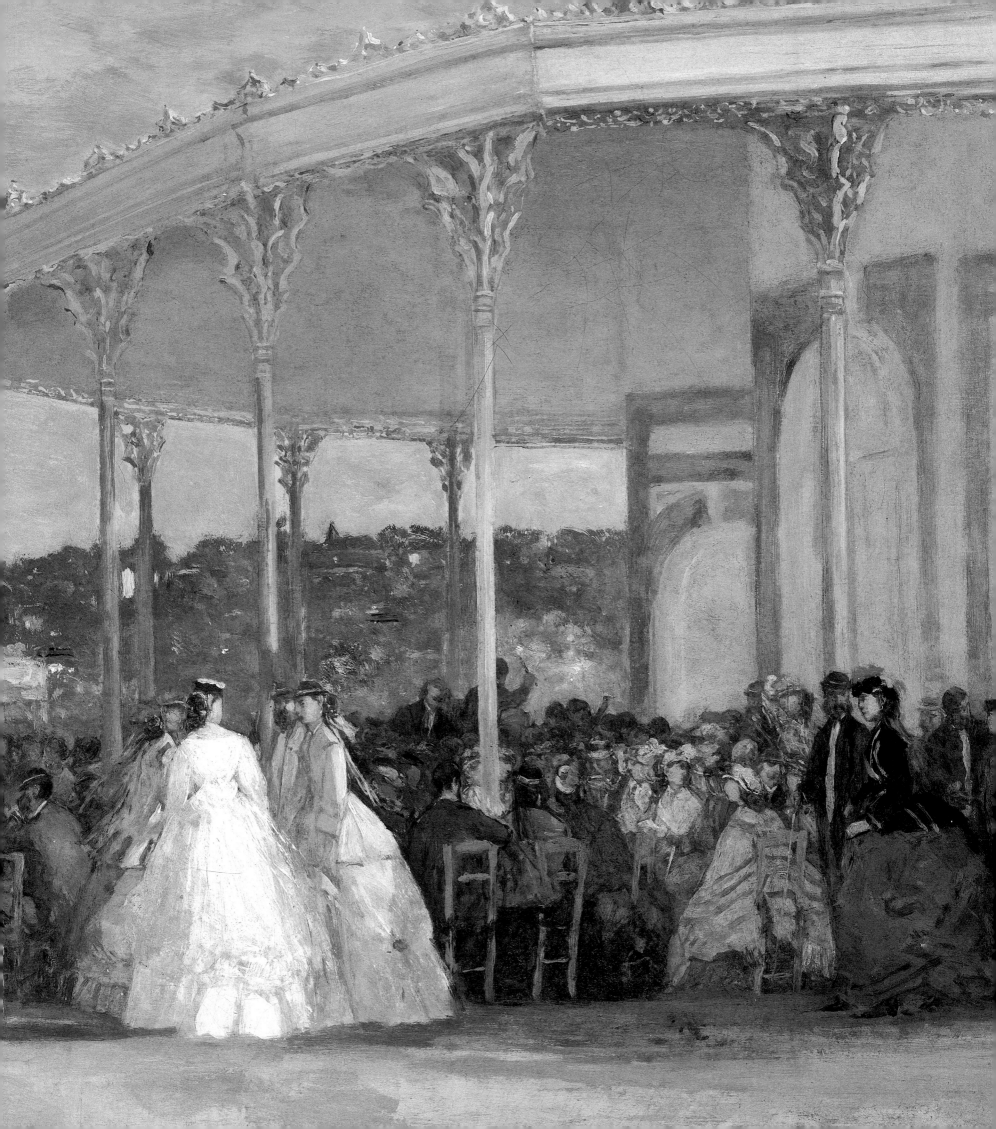

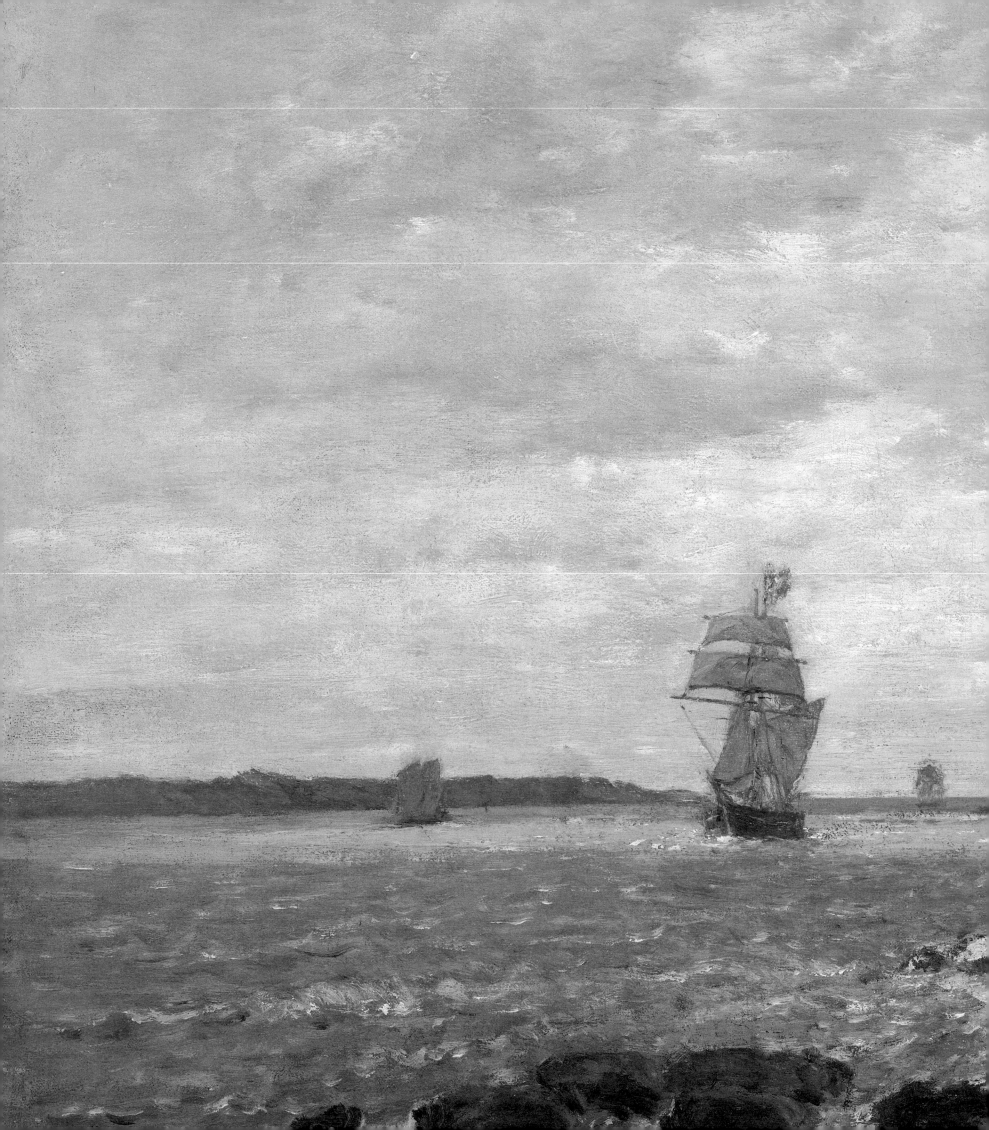

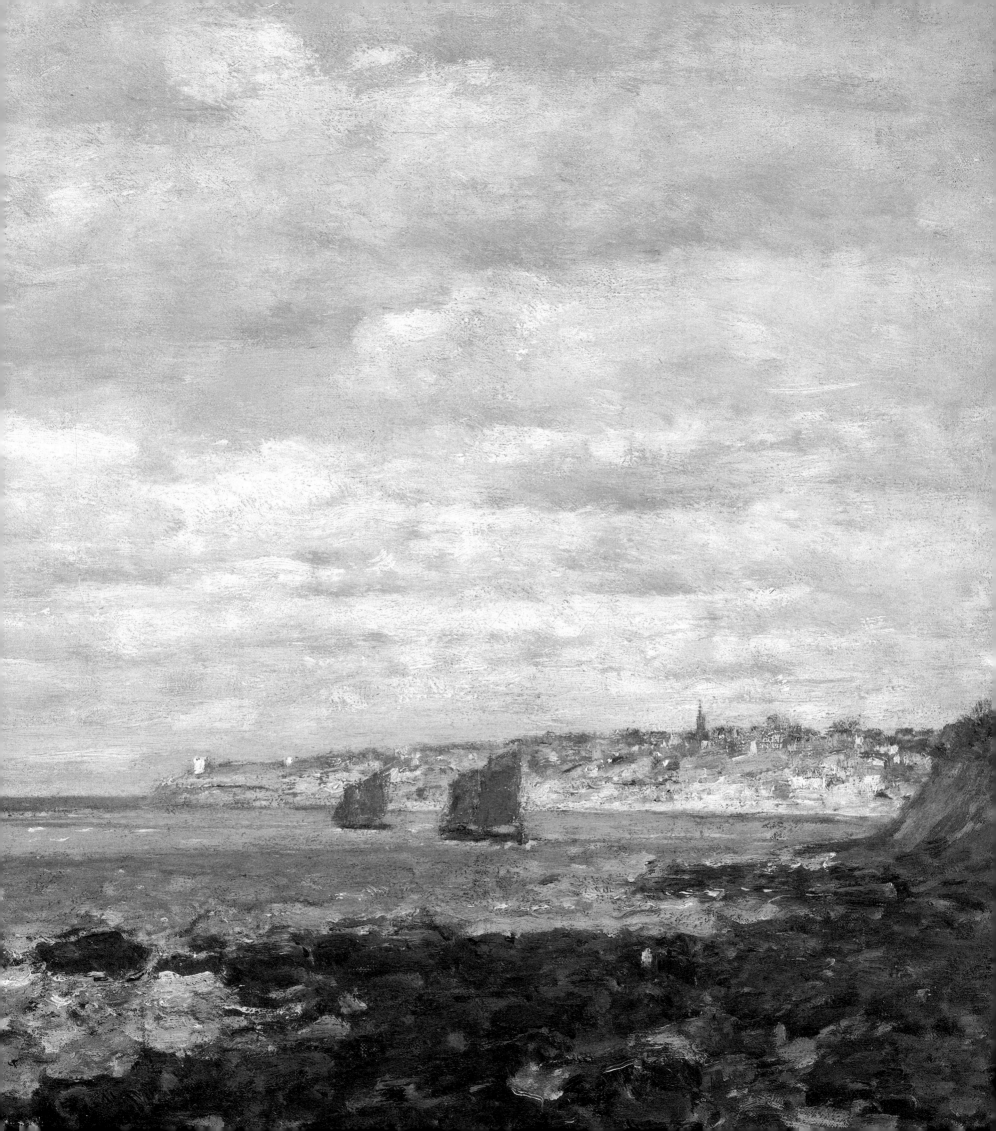

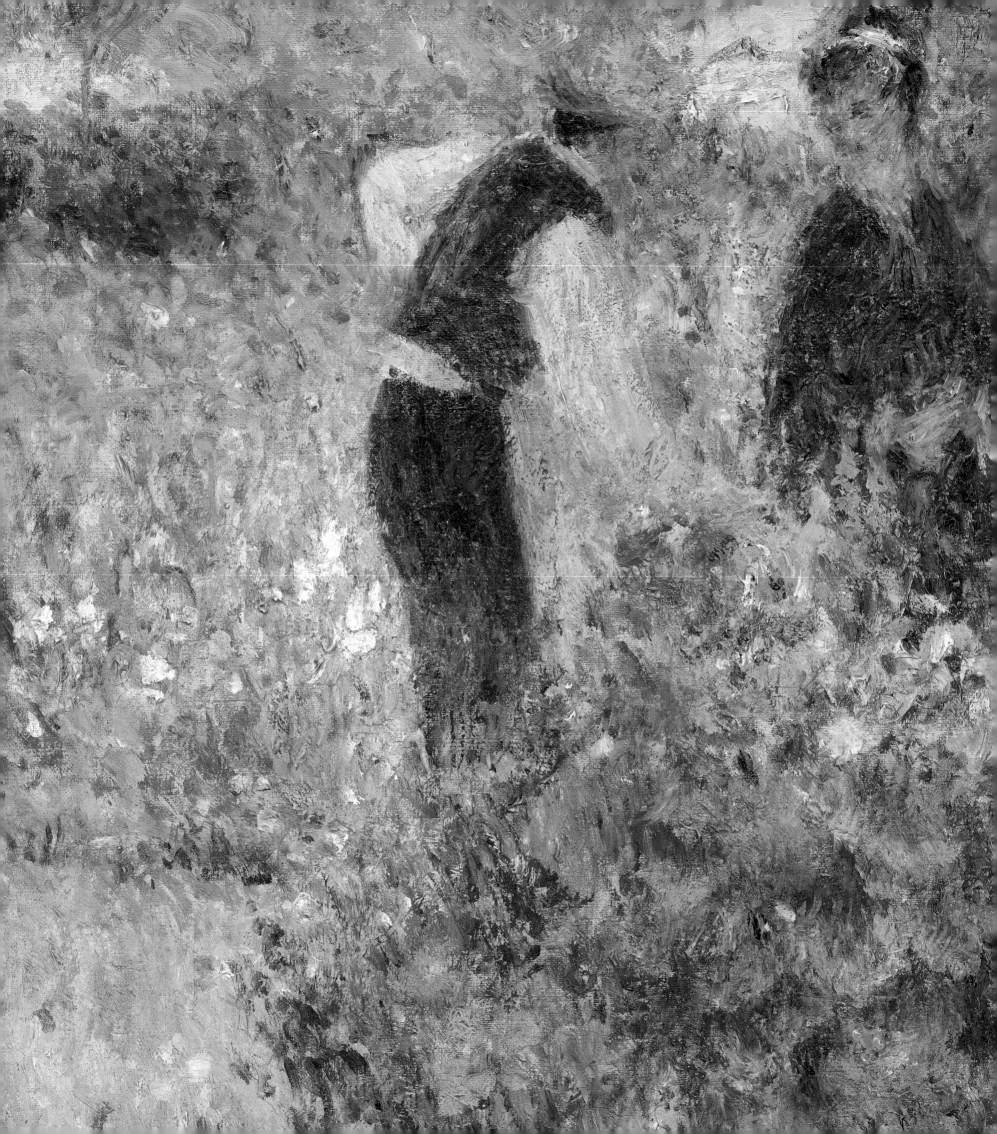

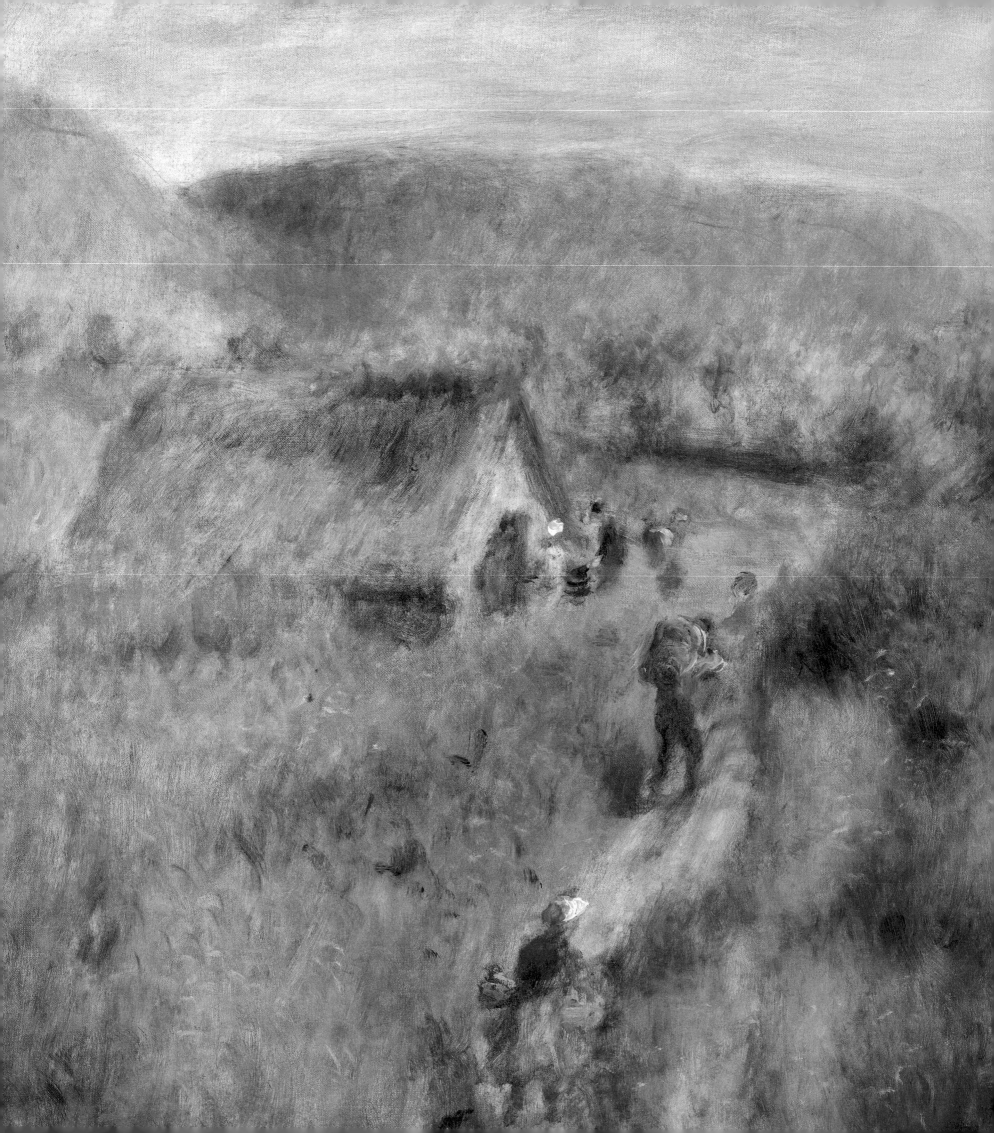

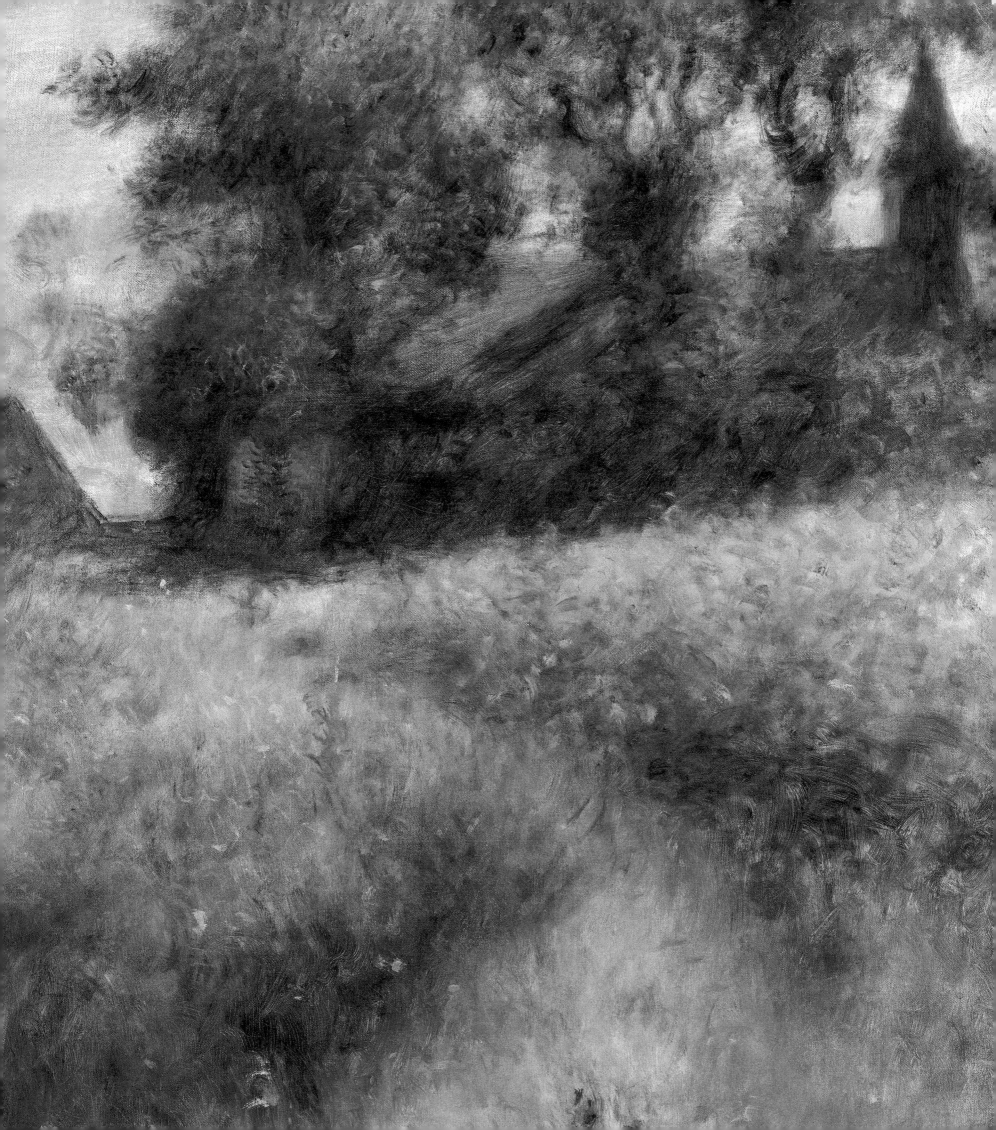

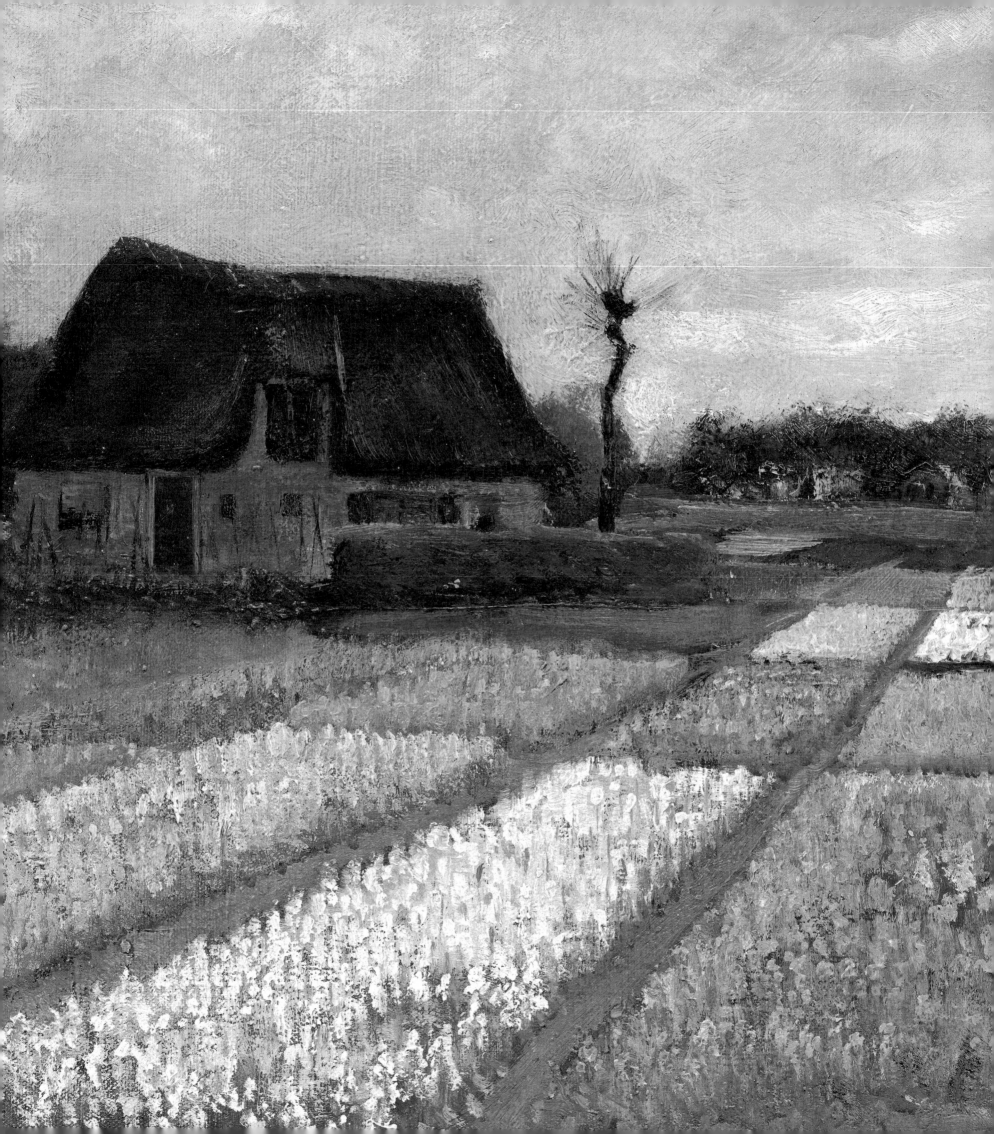

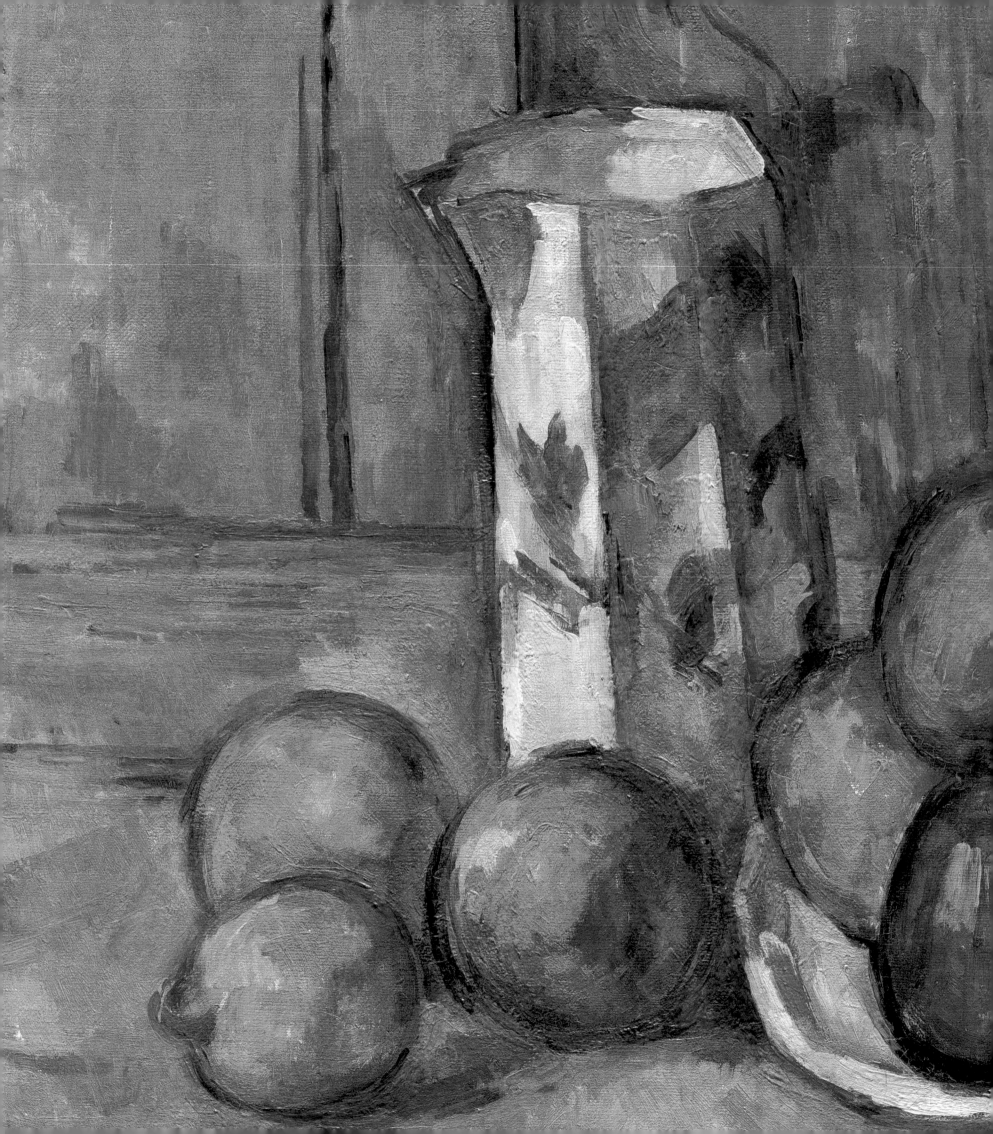

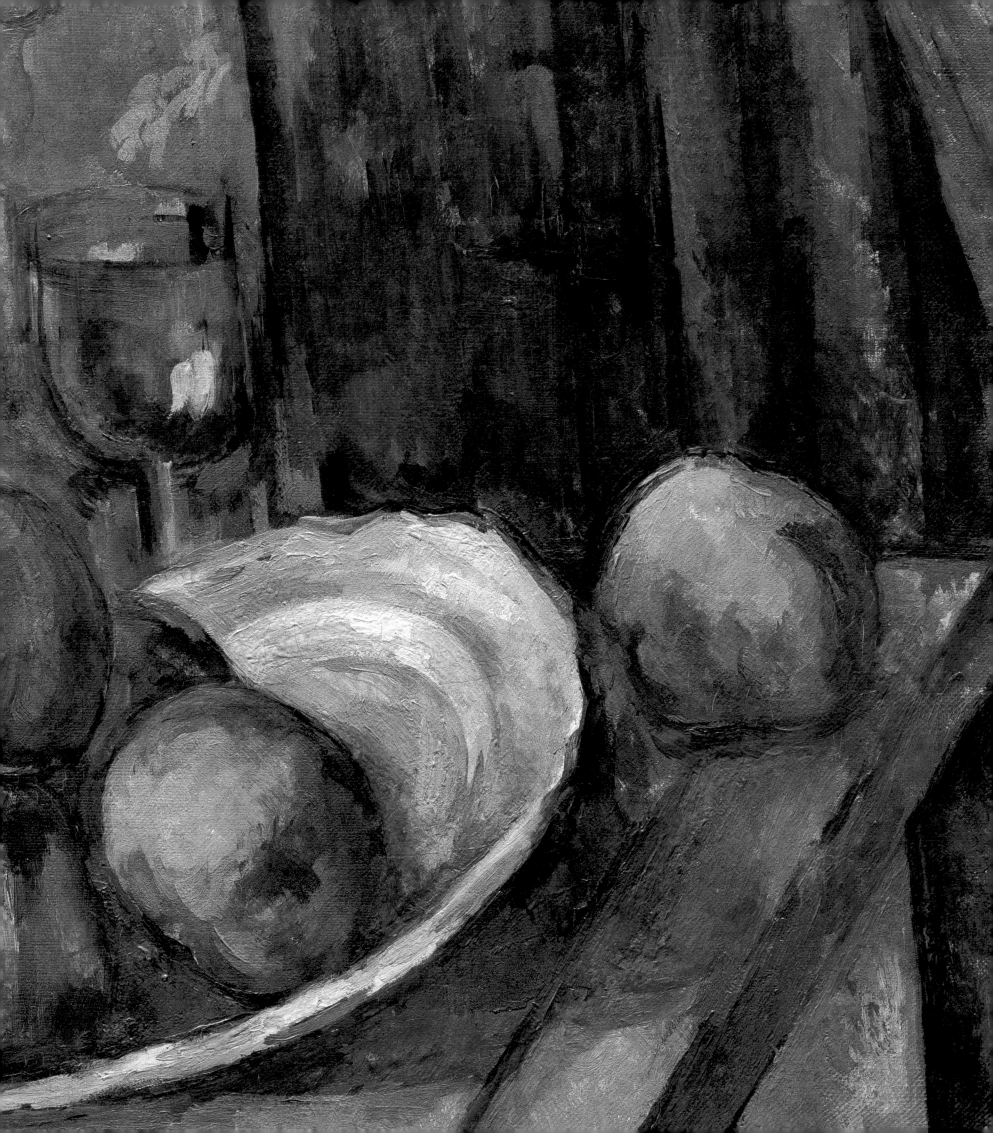

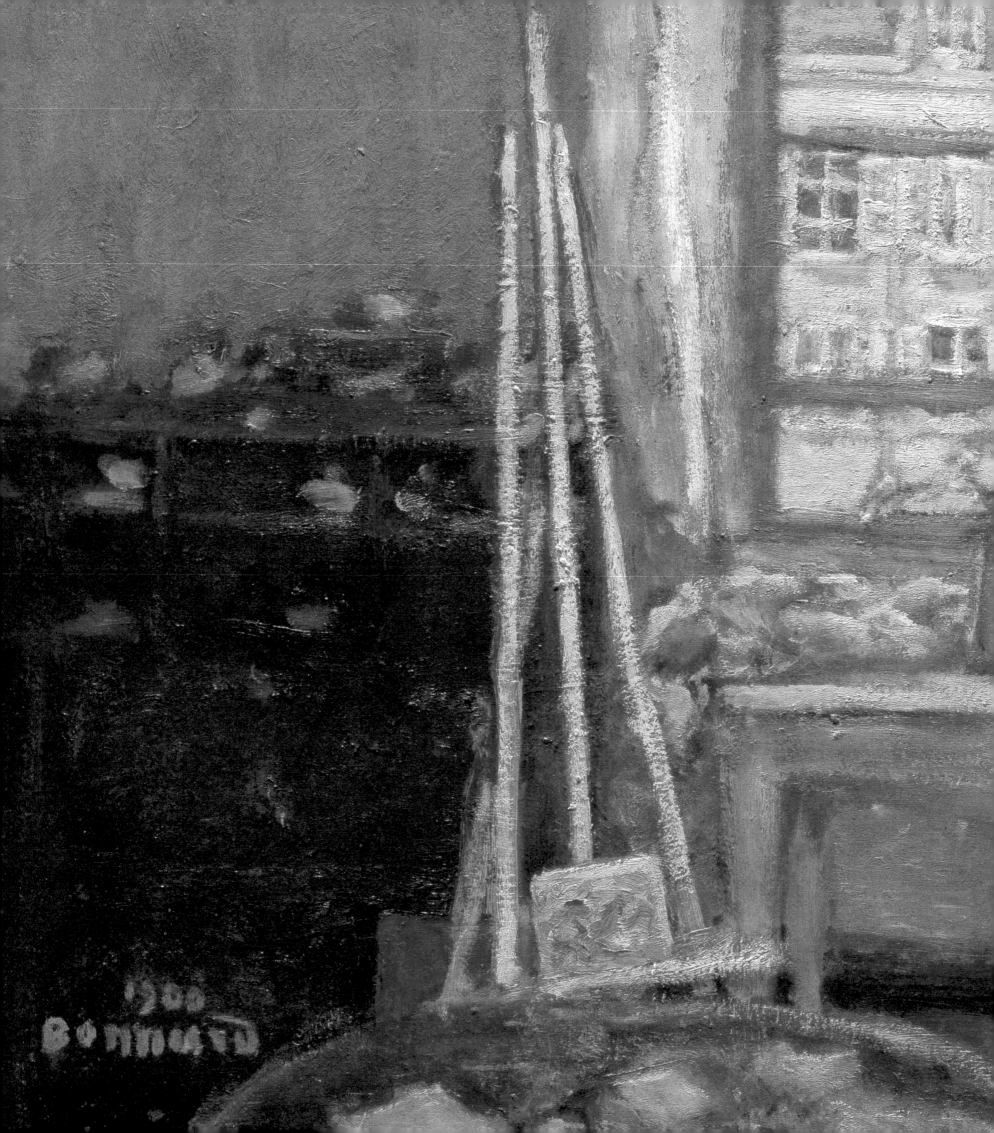

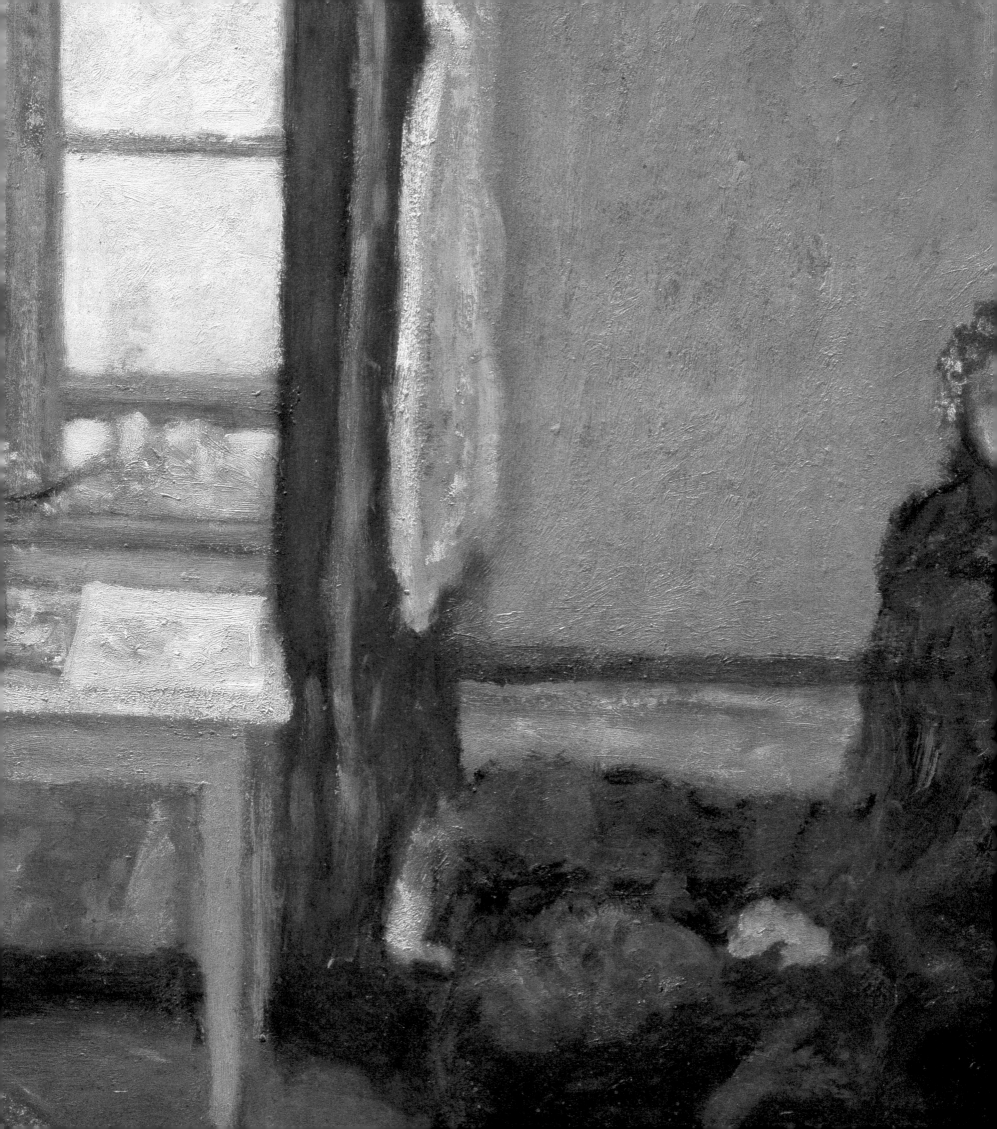

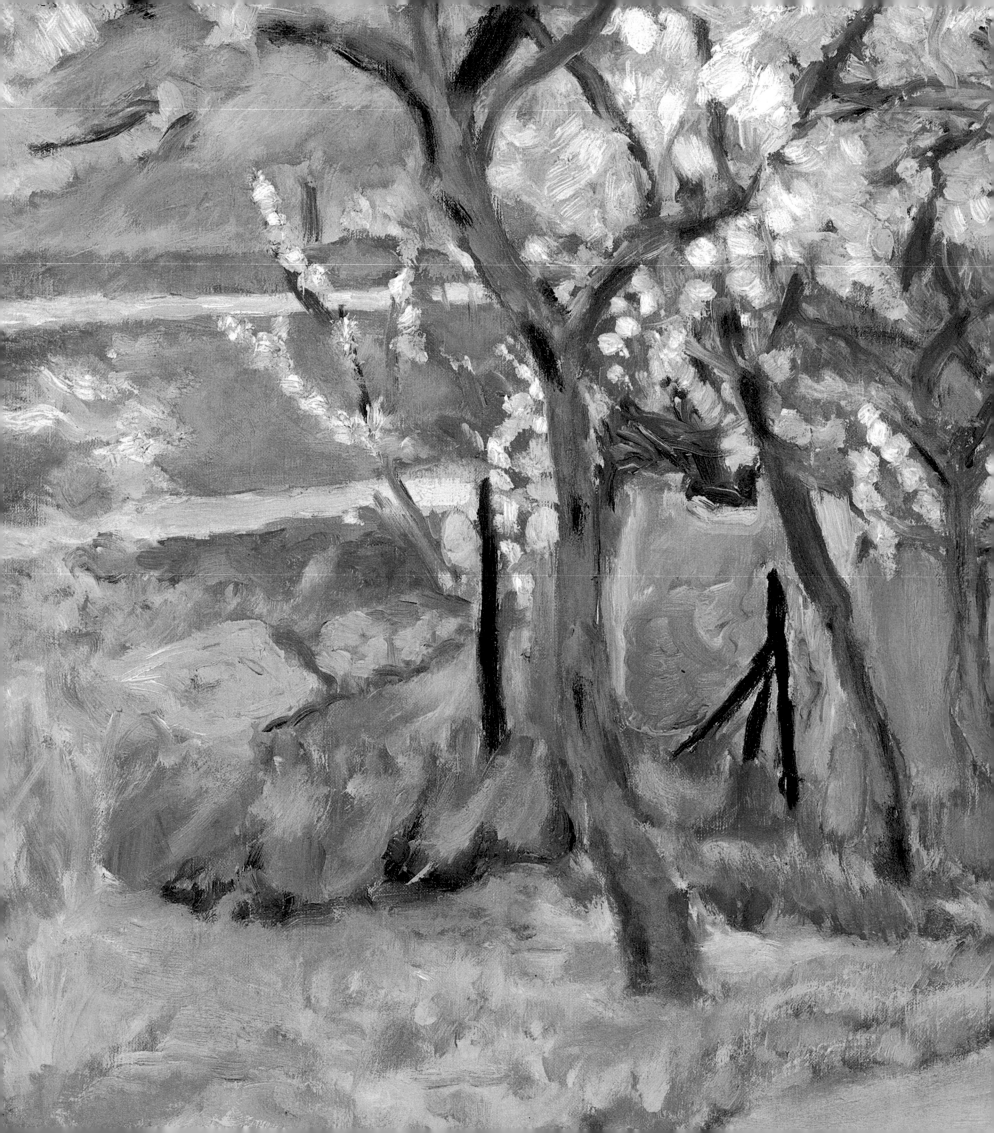

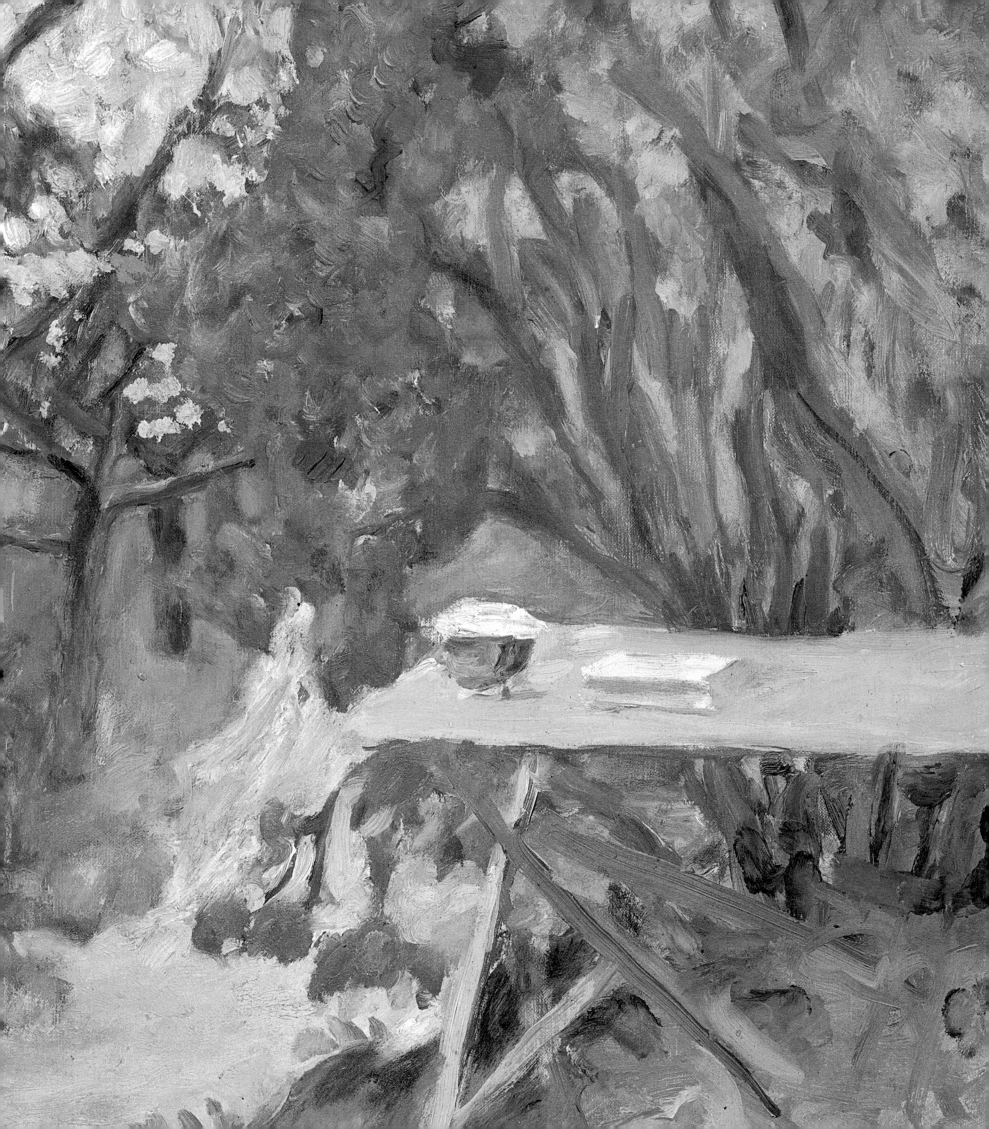

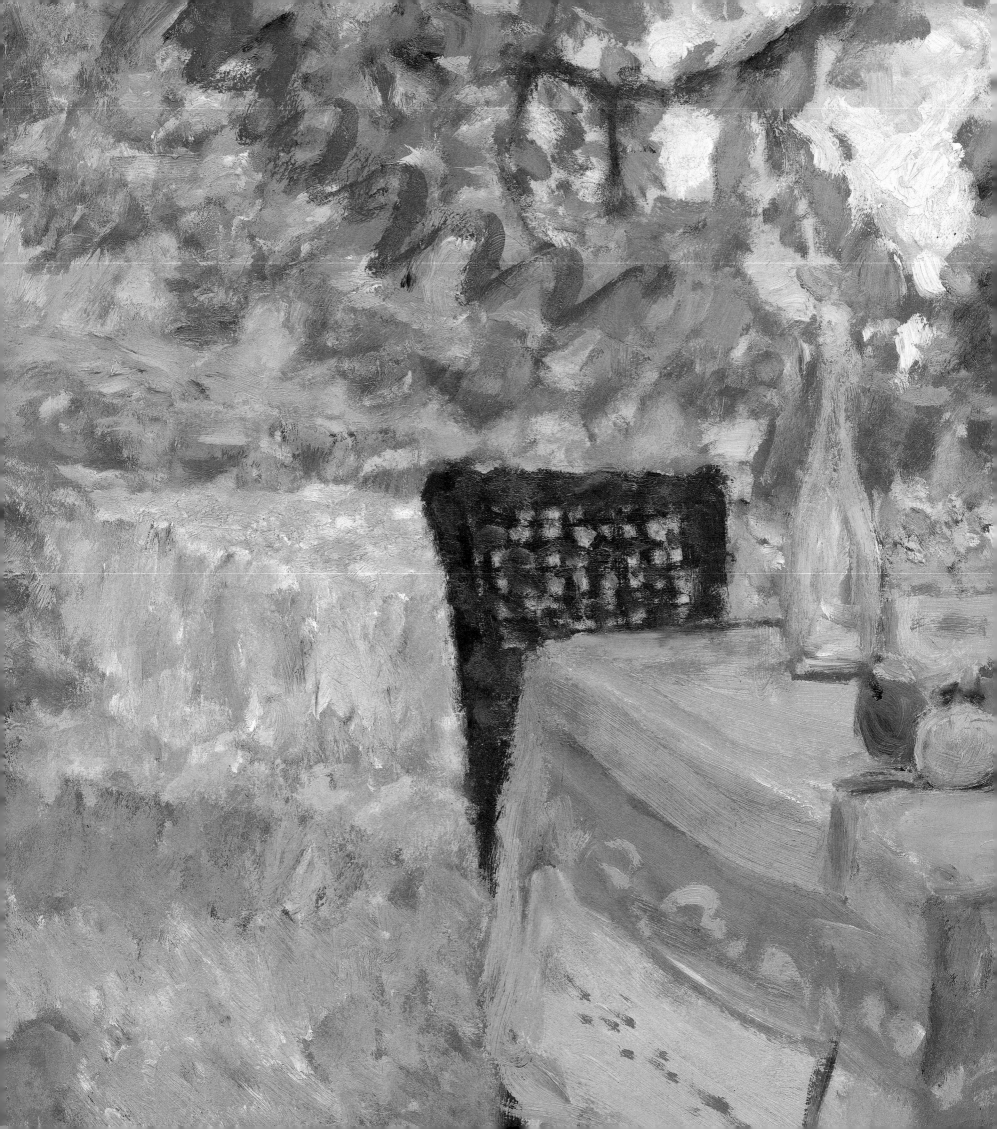

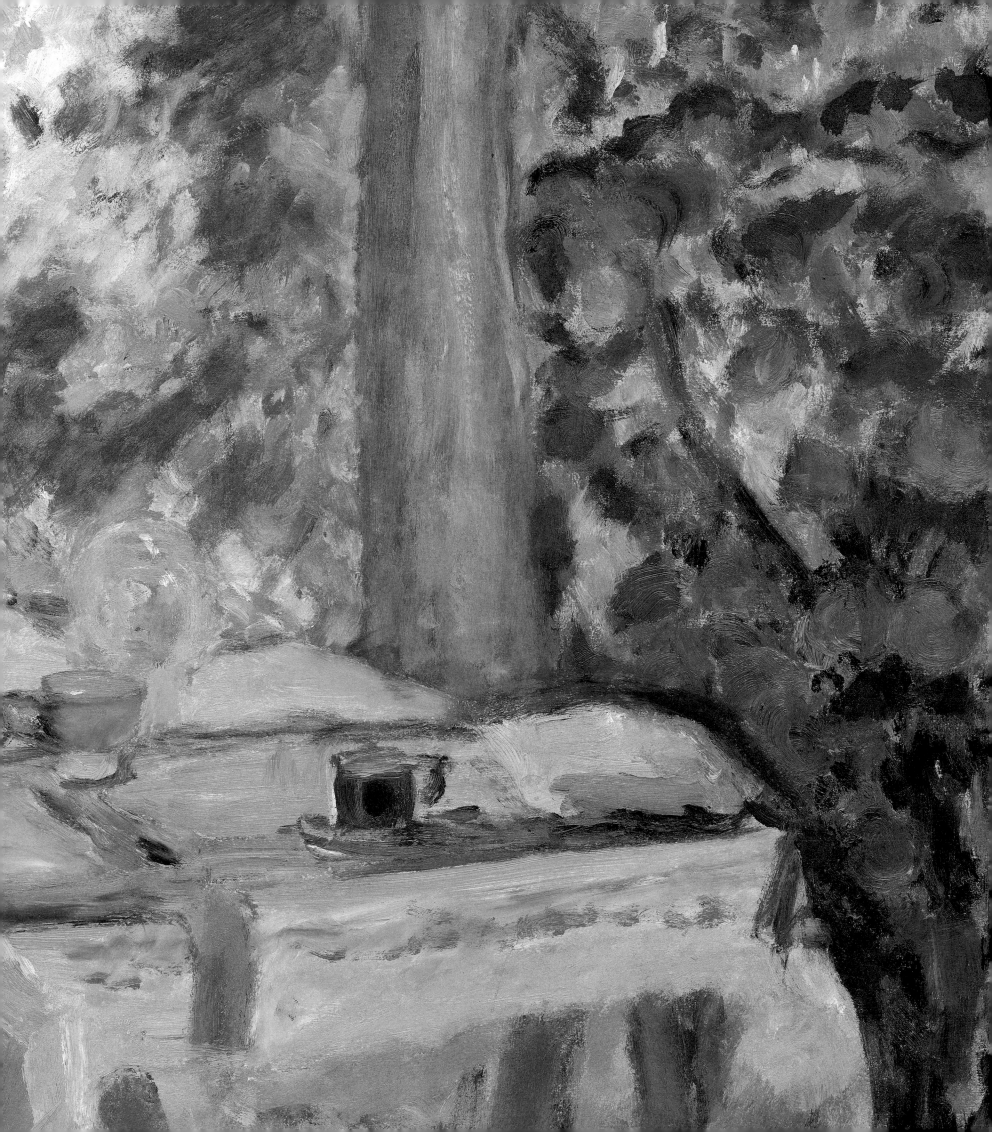

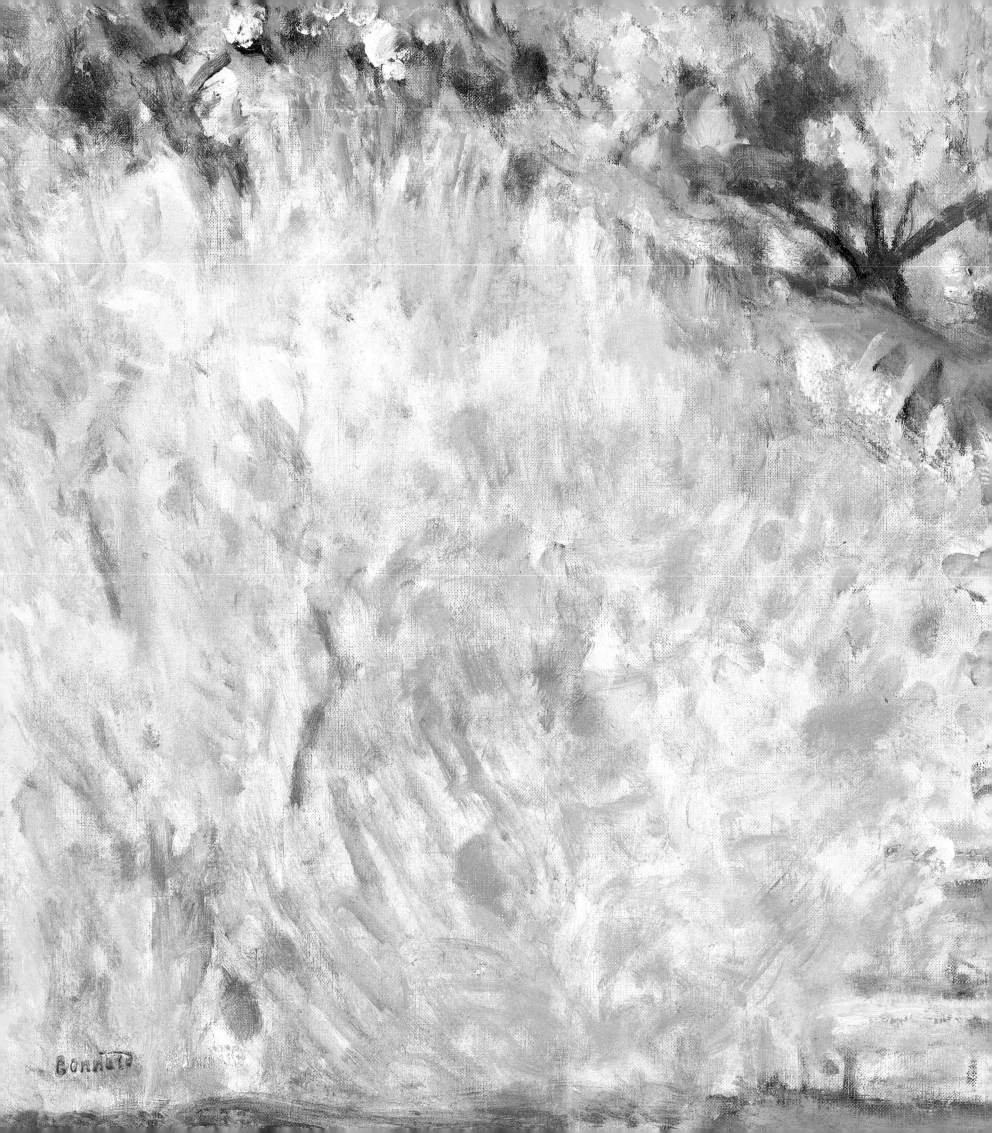

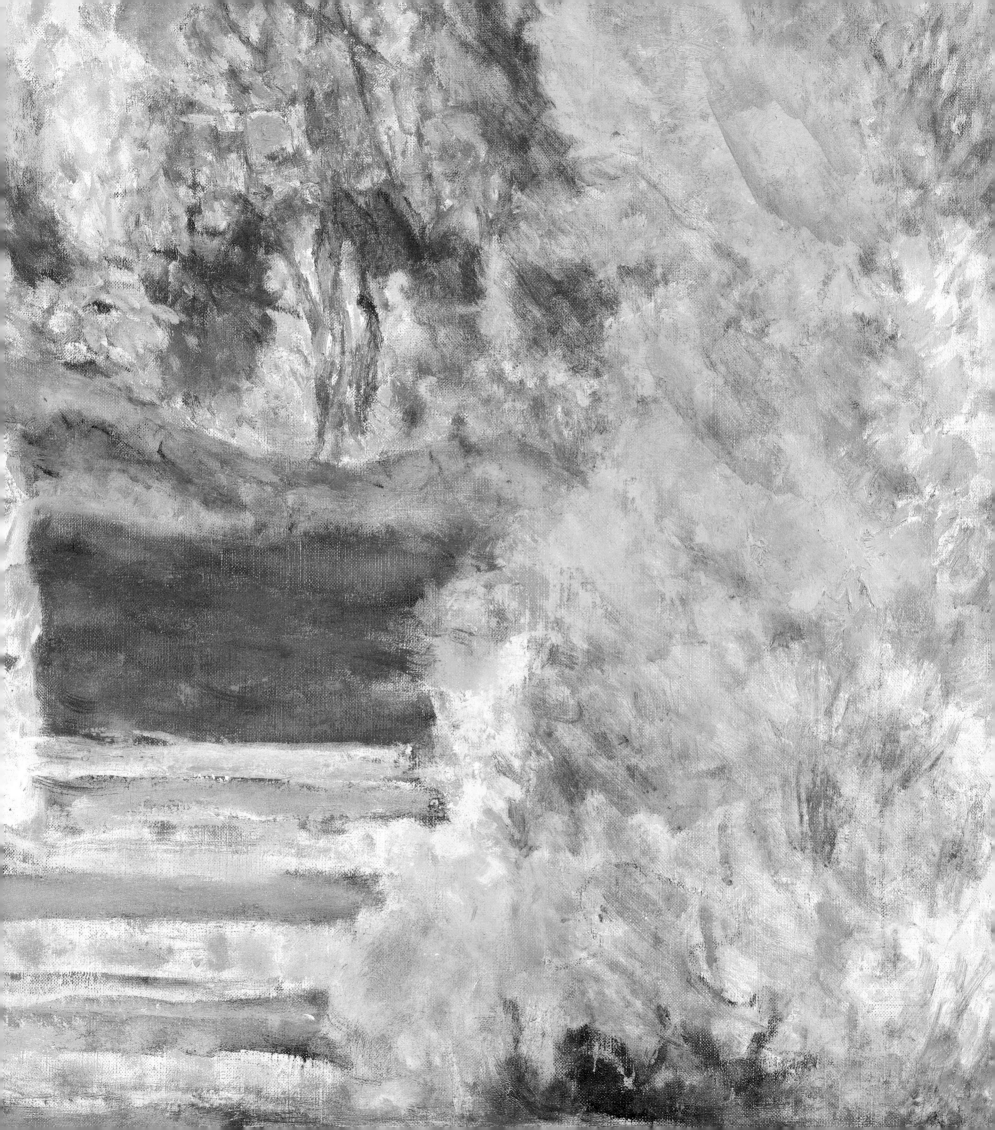

Previous details
(in order of appearance)

Alfred Sisley (pl. 5)
Alfred Sisley (pl. 6)
Alfred Sisley (pl. 7)
Eugène Boudin (pl. 8)
Eugène Boudin (pl. 10)
Eugène Boudin (pl. 11)
Eugène Boudin (pl. 12)
Auguste Renoir (pl. 16)
Auguste Renoir (pl. 17)
Vincent van Gogh (pl. 22)
Paul Cézanne (pl. 51)
Pierre Bonnard (pl. 64)
Pierre Bonnard (pl. 65)
Pierre Bonnard (pl. 66)
Pierre Bonnard (pl. 68)

Intimate Impressionism from the National Gallery of Art

Intimate Impressionism from the National Gallery of Art

Mary Morton

National Gallery of Art, Washington
Legion of Honor, Fine Arts Museums of San Francisco

The exhibition is organized by the
National Gallery of Art, Washington.

The Fine Arts Museums of San Francisco's
presentation of the exhibition is made possible by
the President's Circle sponsors, Bank of America and
the Clare C. McEvoy Charitable Remainder Unitrust
and Jay D. McEvoy Trust; the Patron's Circle sponsor,
Greta R. Pofcher; and the Benefactor's Circle
sponsors, Christie's, The Estate of Harriet E. Lang,
and The Wurzel Trust.

Exhibition Dates

Museo dell' Ara Pacis Augustae of the Musei
Capitolini, Rome
October 23, 2013 – February 23, 2014

Legion of Honor, Fine Arts Museums
of San Francisco
March 29 – August 3, 2014

McNay Art Museum, San Antonio
September 3, 2014 – January 4, 2015

Mitsubishi Ichigokan Museum, Tokyo
February 7 – May 24, 2015

Seattle Art Museum
October 1, 2015 – January 10, 2016

Photography Credits

Unless otherwise noted, images are courtesy
National Gallery of Art, Washington; works of art
were photographed by Gregory Williams, Ric Blanc,
or Tricia Zigmund. Cézanne's *Pont de Maincy*, Musée
d'Orsay (fig. 5), photo: Alfredo Dagli Orti/The Art
Archive at Art Resource, NY

Note to the Reader

Unless otherwise noted, all works illustrated in
this volume are from the collection of the National
Gallery of Art, Washington.

Dimensions are given in centimeters, height
preceding width, followed by inches.

Produced by the Publishing Office
National Gallery of Art, Washington
www.nga.gov

Judy Metro, *editor in chief*
Chris Vogel, *deputy publisher and production manager*
Wendy Schleicher, *design manager*

Designed by Brad Ireland
Edited by Caroline Weaver

Sara Sanders-Buell, *photography rights coordinator*
John Long, *assistant production manager*
Mariah Shay, *production assistant*

Typeset in TiinaPro
Separations by Prographics
Printed on Gardapat Kiara and Munken Print
by Graphicom, Verona

Library of Congress Cataloguing-in-Publication Data

National Gallery of Art (U.S.)
 Intimate impressionism from the National Gallery
of Art/Mary Morton.
 — 1st ed.
 pages cm
 Issued in connection with an exhibition organized
by the National Gallery of Art, Washington, and
held at Museo dell' Ara Pacis Augustae, Rome, Italy;
Legion of Honor, San Francisco, California; McNay
Art Museum, San Antonio, Texas; Mitsubishi
Ichigokan Museum, Tokyo, Japan; and Seattle
Art Museum, Seattle, Washington. Includes
bibliographical references and index.
 ISBN 978-0-89468-386-2 (alk. paper)
1. Impressionism (Art) — France — Exhibitions.
2. Painting, French — 19th century — Exhibitions.
3. Painting, French — 20th century — Exhibitions.
4. Painting — Washington (D.C.) — Exhibitions.
5. National Gallery of Art (U.S.) — Exhibitions.
I. Morton, Mary G. Ailsa Mellon Bruce. II. Title.
 ND547.5.I4N285 2014
 759.4074'753 — dc23
 2013038229

10 9 8 7 6 5 4 3 2 1

Contents

Forewords 7
Acknowledgments 11

Ailsa Mellon Bruce:
Art Collector and Patron of the National Gallery of Art 13

Plates 29
 Painting Outdoors 30
 Artists Portraits 70
 Friends and Models 82
 Still Lifes 104
 Bonnard and Vuillard 116

Index of Artists and Titles 146

Foreword

San Francisco

The Fine Arts Museums of San Francisco hold many outstanding impressionist and post-impressionist paintings that are beloved by visitors to the Legion of Honor. Works by Édouard Manet, Claude Monet, Auguste Renoir, Camille Pissarro, Georges Seurat, and Vincent van Gogh are among the collection's highlights. These paintings are frequently requested for loan to other museums for special exhibitions, and staff and visitors alike often note their temporary absences. Yet sharing these works with audiences worldwide is one of the significant pleasures and responsibilities in our ongoing care for the collections. The gallery that displays our impressionist and post-impressionist paintings is recognized for its quality and diversity, and it is one of the most treasured spaces of the Beaux Arts–style building that suits these pictures so well.

Equally beloved is the series of galleries in the I. M. Pei–designed East Building of the National Gallery of Art that is devoted to intimately scaled works by artists of the same era, ranging from Eugène Boudin to Édouard Vuillard. We are delighted to present a group of these paintings in the first American venue for *Intimate Impressionism from the National Gallery of Art*. Many are relatively small in size: they invite close scrutiny and reward the attentive viewer with their charm and fluency. Their impact is grounded in their quality and variety of subject matter, including still lifes, portraits, and landscapes painted en plein air. The dimensions of these paintings are typically a result of their intended function, which was for display in domestic interiors. Accordingly, many works from this selection, including studies of the artists' favorite places and depictions of people familiar to them, often became gifts shared among friends.

The harmony, cohesion, and quality of the selection presented in *Intimate Impressionism* are principally due to their provenance: members of the Mellon family formerly owned the majority of the paintings on loan. The cabinet pictures collected, enjoyed, and then donated to the National Gallery of Art by Ailsa Mellon Bruce and her younger brother, Paul Mellon, demonstrate the discerning eye and philanthropy instilled in them by their father, Gallery founder Andrew W. Mellon. The Mellon family's collective gift to the nation is one of the most significant cultural legacies in our country's history. It is with great pleasure that we welcome these paintings to San Francisco so that they may be studied closely and enjoyed by our visitors.

In fact, *Intimate Impressionism* represents a reunion of sorts: Ailsa Mellon Bruce lent many of these pictures to the Legion of Honor in 1960. Five years earlier, she had acquired the impressionist and post-impressionist paintings collection of the successful couturier Captain Edward W. Molyneux. He purchased many of these works directly from the artists' dealers or, in some cases, the artists' descendants, which gave his collection considerable cachet. Although Ailsa declined to take credit for assembling the Molyneux collection when it was presented in San Francisco, she impressed her personal taste on it between the 1960 exhibition and her death in 1969, when it was bequeathed to the National Gallery of Art. We are very pleased to welcome the return of these paintings to the Legion of Honor, along with many others that have not been shown here before.

Special thanks are given to the project's early donors, the President's Circle sponsors, Bank of America and the Clare C. McEvoy Charitable Remainder Unitrust and Jay D. McEvoy Trust; the Patron's Circle sponsor, Greta R. Pofcher; and the Benefactor's Circle sponsors, Christie's, The Estate of Harriet E. Lang, and The Wurzel Trust. Additional thanks are extended to Melissa Buron, assistant curator of European art, who managed the exhibition through its preparation and installation. Sincere gratitude is owed to Diane B. Wilsey, president of the board of trustees, for her support and enthusiasm, and to Richard Benefield, deputy director of museums, for his role in bringing this project to San Francisco. We also gratefully acknowledge the assistance of Julian Cox, founding curator of photography and chief administrative curator at the Museums. Krista Brugnara and Hilary Magowan in the Museums' exhibitions department provided valuable guidance during the organizing stages and presentation of this exhibition. This project was further supported by contributions from our conservation, registration, and graphic design departments. And we are, of course, indebted to our colleagues at the National Gallery of Art, including Earl A. Powell III, director; Mary Morton, curator and head of the department of French paintings; and the exhibitions team.

Colin B. Bailey
Director of Museums, Fine Arts Museums of San Francisco

Foreword

Washington

For many visitors to the National Gallery of Art, the discovery of the intimately scaled impressionist and post-impressionist works that hang in a special sequence of rooms on the ground floor of the East Building is a particular delight. The appealing coherence of this installation is in part due to the degree to which later nineteenth-century French avant-garde painters sought similar aesthetic goals. Turning away from literary subjects, they developed luminous, brightly colored images of their immediate environment. Their highly individual expressions are particularly poignant on a small scale. These paintings propose pleasure and amusement, and in general they are personal in subject matter — portraits of family members and friends, views of a favorite garden, quiet meditations on the color and texture of fruit or flowers, corners of a familiar apartment.

The core of this group of paintings was formed by Ailsa Mellon Bruce and Paul Mellon, the daughter and son of the Gallery's founder, Andrew W. Mellon. His first born, Ailsa was his close companion and served as his hostess at official social functions during his years as secretary of the Treasury in the 1920s. She learned about the art market and art collecting from her father as he amassed what would be the foundational collection for the National Gallery of Art. After his death in 1937, and particularly in the decades following World War II, Ailsa devoted her energies and resources toward building a collection of significant old master paintings for the Gallery, and of impressionist and post-impressionist paintings for herself. At her death in 1969, her personal collection came to the Gallery. Ailsa's younger brother, Paul, was an avid collector of British paintings and sporting art and, with his second wife, Rachel Lambert Lloyd, of French impressionism and post-impressionism. Like Ailsa, Paul and "Bunny" Mellon bought major masterpieces for the Gallery as well as smaller works for their home. Their efforts on behalf of the Gallery's collection cemented the institution's role as one of the world's leading repositories of French modernist painting.

These two committed patrons made building the national art collection part of their life's work, and while they funded the acquisition of many of the Gallery's greatest masterpieces, they also gathered together works of art to enjoy privately before giving them to the nation. From the sunlit spring meadows of Alfred Sisley to the riveting still lifes of Édouard Manet and Paul Cézanne to the fabulous Nabi interiors of Pierre Bonnard and Édouard Vuillard, these vivid paintings present the inspired innovations in color, brushwork, and composition that make later nineteenth-century French painting one of the great moments in the history of art.

Alongside the Mellon and Mellon Bruce paintings are a dozen paintings from other patrons of the National Gallery of Art. The foundational gifts of Peter A. B. Widener, Joseph E. Widener, and Lessing J. Rosenwald include the small-scaled paintings listed in this catalogue by Jean-Baptiste-Camille Corot, Edgar Degas, and Jean-Louis Forain. In addition to his institutionally transformative collection of impressionism and post-impressionism, which dominates the Gallery's West Building installation, Chester Dale left acquisition funds used to buy such paintings as Antoine Vollon's extraordinary

Mound of Butter and Edgar Degas's *Horses in a Meadow*. Among other late nineteenth-century French pictures given to the Gallery by statesman W. Averell Harriman in memory of his wife Marie are two small works by Cézanne — his concise yet powerful *Battle of Love* and his equally precise *Still Life with Milk Jug and Fruit*. Luscious paintings by Auguste Renoir were given by the great pianist and composer Vladimir Horowitz, by educator and philanthropist Margaret Seligman Lewisohn, and by Mrs. Benjamin Levy and Dr. and Mrs. (Adele) David M. Levy. Mrs. Adele R. Levy also gave the exquisite Manet still life *Oysters*. Intimately scaled, these vibrant, freely painted works adorned the living spaces of the collectors who ultimately gave them to the Gallery.

These patrons wished to share their treasures with the people of the United States, and it gives us great pleasure to see them travel to other states in the union and two venues abroad. The works included were selected by Mary Morton and Kimberly Jones, our curators of French paintings here at the Gallery. For their enthusiasm and collegiality, we are grateful to our colleagues at our partner venues: the Museo dell' Ara Pacis Augustae of the Musei Capitolini, Rome; Legion of Honor, Fine Arts Museums of San Francisco; McNay Art Museum, San Antonio; Mitsubishi Ichigokan Museum, Tokyo; and Seattle Art Museum.

Earl A. Powell III
Director, National Gallery of Art

Acknowledgments

This tour of smaller-scaled impressionist and post-impressionist paintings from the National Gallery of Art and the accompanying catalogue are the result of the collaborative effort of many colleagues and friends of the Gallery. Supported by the director, Earl A. Powell III, and deputy director and chief curator, Franklin Kelly, chief of exhibitions D. Dodge Thompson enlisted the Italian and domestic venues; Joseph Krakora, executive officer for development and external affairs, and Ellen Bryant, deputy to the executive officer, arranged our Japanese venue. Associate curator Kimberly Jones collaborated on the selection of works for the exhibition and helped orchestrate the tour in-house. Curatorial assistants Nina O'Neil and Michelle Bird supported the show's organization in innumerable ways.

Research on Ailsa Mellon Bruce was facilitated by Maygene Daniels, Gallery archivist, who suggested sources and shared her deep knowledge of institutional history. Jean Henry facilitated access to archival documents; Nancy Yeide, head of curatorial records and files, shared information on Ailsa Mellon Bruce as well as her seminal work on Edward Molyneux; Gallery historian Philip Kopper shared invaluable advice and information.

In the publishing office, Judy Metro, editor in chief, offered counsel on all aspects of the book production, with Caroline Weaver editing with intelligence and sensitivity and Brad Ireland striving for a fresh, appropriate design. They were aided by Chris Vogel, deputy publisher; Julie Warnement, senior editor; and Sara Sanders-Buell, photography rights coordinator.

Many of the paintings required cleaning and conservation prior to traveling. Under the direction of Jay Krueger, head of paintings conservation, both Ann Hoenigswald and Elizabeth Walmsley cleaned and studied these much-loved works, resulting in not only refreshed paint surfaces but also a deeper understanding of the objects themselves.

Chief registrar Michelle Fondas and her staff, especially Judy Cline, tirelessly researched a complicated, multivenue tour crossing sea and land and back again, working to accommodate our partners' schedules while ensuring safe transit for our pictures. Lisa MacDougall managed voluminous loan documents. The collection received special preparation for the rigors of travel, exhaustively overseen by Steve Wilcox and Andrew Krieger with the expertise of Lewis Schlitt, Jesse Clark, and Michael Russell.

Other colleagues at the Gallery who supported the project include Elizabeth Croog, secretary general counsel; Nancy Breuer, deputy secretary and deputy general counsel; Alan Newman, chief, division of imaging and visual services; Lorene Emerson, head of photographic services; Nancy Hoffmann, assistant to the treasurer for risk management and special projects; Christine Myers, chief development and corporate relations officer; Alicia Thomas, senior loan officer; and Deborah Ziska, chief press and public information officer.

Mary Morton
Curator and Head of the Department of French Paintings, National Gallery of Art

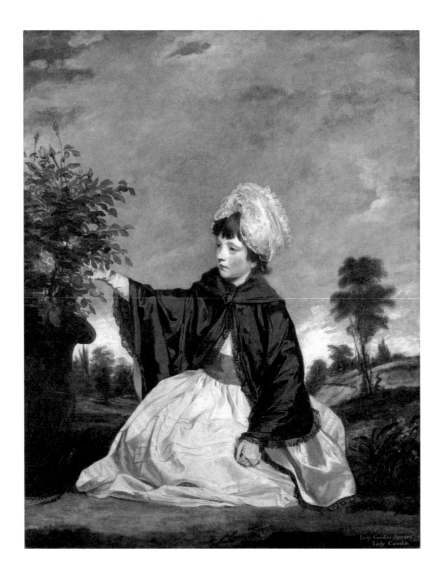

Figure 1
Joshua Reynolds, *Lady Caroline Howard*, 1778,
oil on canvas, National Gallery of Art, Andrew W.
Mellon Collection

Ailsa Mellon Bruce:
Art Collector and Patron of the National Gallery of Art

Mary Morton

Among the most beloved exhibition spaces at the National Gallery of Art today are those devoted to small French paintings on the ground level of the East Building, which was designed by I. M. Pei as a major addition to the museum on the Mall and opened in 1978. In counterpoint to the grand galleries of John Russell Pope's West Building and the open, modern spaces of the East Building, this sequence of intimate galleries holds works that were collected largely by Paul Mellon and Ailsa Mellon Bruce, Gallery founder Andrew W. Mellon's two children. Both were major patrons of the Gallery in their own right, with multiple direct gifts of funds and significant works of art to their credit. The works in these small galleries were pictures that they had bought and lived with in their homes, but always intended to give to the nation. The broad appeal of these paintings stems from this sense of intimacy. These are pleasure paintings — works made for private enjoyment, at home, every day.

Much has been written about Paul Mellon, whose patronage of and devotion to the Gallery provided crucial financial and moral support to the institution from the late 1940s until his death in 1999. Older than Paul by six years, his sister Ailsa is less well known. This is due in part to both the famous Mellon "passion for privacy" — in her case, an aggressive resistance to recognition for spectacular acts of generosity — and a lifetime of physical, mental, and emotional ill health. Increasingly reclusive in her mature years, Ailsa was averse to the generic practice of collector-patrons: adding one's name to credit lines and galleries, appearing in the society pages and art press, and attending openings of exhibitions that included one's gifts.

Regardless, she belongs to the small group of Gallery founding benefactors, her patronage on a par with that of her brother Paul, Peter A. B. Widener, Joseph E. Widener, Samuel H. Kress, Rush Harrison Kress, Lessing J. Rosenwald, and Chester Dale. Her close working relationship with John Walker, the Gallery's chief curator from 1939 to 1956 and its director from then until 1969, resulted in the acquisition of many of the Gallery's most celebrated masterpieces — including the impressionist and post-impressionist paintings that are at the core of this exhibition tour — as well as the initial funding for the construction of I. M. Pei's East Building and the library and scholars program that it houses.

Andrew's Aide: The 1920s and 1930s

Ailsa was born into extreme affluence in 1901, growing up in Pittsburgh where her father had built a fortune in the banking business. She was the daughter of Andrew Mellon and his much younger English bride, Nora McMullen, who had moved to Pittsburgh to set up house with her husband in 1900. In his memoir *Reflections in a Silver Spoon*, Paul describes Ailsa as a high-spirited tomboy full of energy and imagination. She doted on her parents and her brother, but her intense affections were blunted by her mother's flight from her

unhappy marriage, her father's fierce recrimination, and a prolonged and vicious divorce battle in which the children were shuttled back and forth in a bitter game of revenge. The wrenching absence of her mother and the serial departures of hired mother figures, as well as the provincial Pittsburgh rumor mill that fed on the scandalous dysfunctions of the fabulously rich family, severely damaged Ailsa's prepubescent emotional life. Her austere father — by turns affectionate, controlling, dismissive, and coldly condescending — arranged for her to attend Miss Porter's School in Farmington, Connecticut, where she seems to have been unhappy. She did not attend college, but accompanied her father to Washington, DC, when he was appointed secretary of the Treasury in 1921. During his tenure, from 1921 to 1932, she served as his social hostess, maintaining the supporting role of a government official's wife, even after her own marriage to David K. E. Bruce in 1926.

Ailsa gained experience in the art market by working with her father on his increasingly lavish interiors: the Pittsburgh house at Woodland Road, the Washington apartment in the McCormick Building on Massachusetts Avenue and 18th Street NW, and the London embassy residence at 14 Prince's Gate, in 1932, the year that Andrew was ambassador to the Court of Saint James.[1] She became acquainted with her father's dealers — Charles Carstairs at Knoedler's, the experts at French & Company, and, most notoriously, the dealer impresario Joseph Duveen — as Andrew built a spectacular collection of old master paintings. Ailsa assisted her father with perhaps the greatest art deal of the century, the acquisition of twenty-one masterpieces from the Russian royal collection at the Hermitage from 1930 to 1931.[2]

One story that recurs in the Mellon family literature regarding Ailsa's relationship with art and the Gallery involves Joshua Reynolds' *Lady Caroline Howard* (fig. 1), which Andrew acquired from Duveen in 1926, and which was hung in Ailsa's corner bedroom during her final months in the McCormick Building apartment she shared with her father. She loved this charming image of a sweet-looking, well-born girl kneeling to pluck a rose, the fresh tonalities of her complexion alluding to her childish innocence, while her precociously fashionable mantilla and cap look toward adulthood.[3] Ailsa's emotional response to this image may have been heightened during this most publicly dramatic year of her life, when she left her father's side to fulfill her destiny as a well-married woman and starred in what amounted to a royal wedding at the National Cathedral. She was, in any case, deeply hurt when she learned that her father had included the painting with the collection of works he intended to give to the future National Gallery of Art. Andrew explained to Ailsa that the picture was too important to be enjoyed privately. Paul recalls that she was "very, very upset," which in turn left Andrew feeling bad.[4] Defending himself to his son for an act his children perceived as irredeemably insensitive, Andrew explained to Paul that the Gallery should be felt to be a family project, a gift from all three of them to the nation (fig. 2). Skeptical, perhaps, that Andrew planned the Gallery as anything but a solo act, a "gift to the nation" that was very much individual, Paul chuckled in recounting the episode to his interviewer. At the time, however, it was for Ailsa a painful lesson about public versus private pictures, one that she would not forget.

Marriage and Motherhood

Ailsa's husband David K. E. Bruce was a charming, bright, blue-blooded Marylander — the "Last American Aristocrat," according to his biographer, Nelson D. Lankford. It was an excellent match for Ailsa, and her father and brother were very pleased. Wed in 1926, the couple immediately moved to Rome, where David took up his post as vice consul for the State Department, the first step in his intended career as a diplomat. Ailsa immediately contracted a strange disease that seems never to have been successfully diagnosed. She ran a constant fever, suffered unrelenting pain, and was drained of energy. After

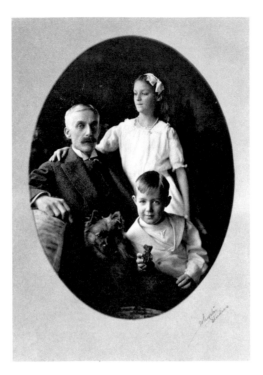

many months, the couple moved back to Washington, but Ailsa experienced bouts
of ill health for the rest of her life. She was also perhaps unprepared emotionally and
practically for marriage. While Paul may have benefited from his older sister's nurturing
protection during the worst years of their parents' divorce, by gendered societal pres-
sures to establish himself as a productive individual, and by his extensive work with the
psychotherapist Carl Jung, Ailsa was by all accounts permanently wounded.[5] Although
David Bruce remained close to Andrew and Paul, working with them on plans for the
Gallery, David and Ailsa increasingly lived apart. The separation was formalized during
the war, when David was stationed in Britain. There he met and fell in love with a dip-
lomat's daughter, Evangeline Bell; he asked Ailsa for a divorce in 1945. She was crushed,
filing for divorce herself in a Florida court as a victim of "mental cruelty."

In the literature on the Mellons and David Bruce, Ailsa is universally blamed for
her failed marriage, with David's apparently immaculate nature casting her personal
failings into relief. Characterizing David Bruce as a shining knight of optimism, his
biographer villainizes Ailsa as a spoiled, self-absorbed hypochondriac, "a knotted
brooding recluse" who ignored the needs of her husband's career.[6] In 2008 Andrew's
biographer, David Cannadine, continued the dichotomy: "He was brilliant, well-read,
outgoing, impeccably mannered, and professionally ambitious; she was self-centered
and aloof, intellectually lazy, inadequately educated, and easily bored, as well as inclined
to hypochondria."[7] Cannadine is straightforward in his account of Andrew Mellon's only
daughter: she was brought up "with little other purpose than to marry well." Having
accomplished this, "her only work in life was to support (as well as to finance) her hus-
band's diplomatic career," to produce children, and to be swayed by aggressive dealers
to spend money on pictures.[8]

There seems to be little in the historical literature to defend Ailsa: no journals, few
letters of substance, and no eloquent literary admirers. In his memoir, Paul Mellon
writes about their childhood together, but Ailsa drops out of his story when they become
adults. Paul had been good friends with David since they were boys and he regretted
losing David's partnership on family matters, including the National Gallery of Art
(with the divorce David resigned his seat on the Gallery board).

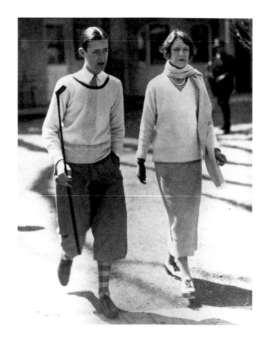

In 1976, at the opening of new galleries at the Carnegie Institute in Pittsburgh devoted
to Ailsa's earlier bequest of her decorative art collection, Paul took the opportunity
to perform what he seemed to feel was a necessary rehabilitation of her reputation:
"I would like you all to see her through my eyes as a happy child, as an attractive young
woman, as a concerned wife and mother and grandmother…as well as an intelligent
philanthropist and a collector of rare discernment and taste"[9] (fig. 3). He described her
as "a dear companion and charming human being" who taught him to love English
poetry — Byron in particular — and remarked on the "cool placidity and quiet beauty"
that "often made her seem rather aloof and inaccessible as well as charmingly enig-
matic." In her younger years, Paul recounted, Ailsa had been quite active and outgoing,
"even boisterous," but after her divorce from David she became shy, more introverted,
less active, "and a little bit of a hypochondriac." Paul challenged her reputation for pas-
sivity with her record as a trustee of the Avalon Foundation, the philanthropic organiza-
tion she established in 1940. According to him, Ailsa rarely missed a meeting and she did
her homework diligently. She asked probing questions that got to the heart of the matter.
She had a keen but subtle sense of humor and a gentle but penetrating irony in her view
of people. The Carnegie speech is particularly valuable given the few details Paul reveals
in his oral history, in which the subject of Ailsa seems an understandably uncomfort-
able one.[10]

Ailsa's life was clearly difficult: a painful, turbulent childhood, absent mother,
emotionally distant father, highly restricted social role, unsuccessful marriage, and bad
health. Sealing the tragic aura of her story, she lost her only child — daughter Audrey
Bruce Currier — in a plane crash in 1967. Despite these difficulties, however, the record
shows a capacity for great pleasure and profound engagement. Although she was shy,
Ailsa enjoyed socializing with her small group of trusted friends and attended parties
where she was reported as being as gay and amusing as any other guest. She had been an
avid traveler, she was admired for her excellent taste in fashion and jewelry, and despite
her protestations against the appellation, she was an ardent art collector and a serious
benefactor. Through her thirty years of work with the Avalon Foundation, she directed
some $67 million to colleges and universities, medical schools and hospitals, youth
programs and community services, churches, environmental projects, and cultural
and arts organizations.

1950s: The Molyneux Collection

Ailsa's achievements as an art collector and patron centered on her close, constructive relationship with John Walker. Just a few years younger than Ailsa, Walker was also born in Pittsburgh to a wealthy family; his boyhood playmates included Paul Mellon (fig. 4). He studied art history with Paul Sachs at Harvard and in Italy with Renaissance scholar Bernard Berenson. Walker had worked as professor in charge of fine arts and assistant director at the American Academy in Rome, and was considering a scholarly life in Europe when he was recruited by David Finley, the Gallery's first director, to organize the initial installation of the nascent National Gallery of Art. In the period leading up to the 1941 opening, he was appointed chief curator. As an art historian and connoisseur, Walker was conversant in all schools of European art. His mission was to expand the Gallery's collection beyond the initial founding gifts. He began working seriously with Ailsa in the years after World War II, her marriage over and her daughter Audrey starting boarding school.[11]

Over two decades, Walker visited Ailsa frequently in New York, where she was living at 2 East 67th Street.[12] They met with dealers, lunched and dined together (often with Ailsa's companion Lauder Greenway), went to the opera, and spent weekends at Ailsa's Long Island estate at Syosset, swimming, reading, and chatting. Walker characterized theirs as a close friendship.[13]

In 1948 Walker asked Ailsa to acquire for the Gallery Bartolomé Esteban Murillo's *Return of the Prodigal Son*, offered by the British dealer Agnew's from the 5th Duke of Sutherland, and in 1949 he encouraged her move ahead on an Édouard Manet flower still life, a small jewel of a painting that she had found at Wildenstein's, for her own collection. In a letter dated January 28 that reveals the nature of their exchange, he wrote, "Thursday I went to Wildenstein's and saw the Manet *Still Life*. It seems to me *very* beautiful. Flower pictures of this importance by Manet are, as you know, extremely rare, and to me his still-life painting is the most satisfactory expression of his genius. I do hope you get it, for I am sure you will always love the painting. When are you coming to Washington to see the Murillo?"[14]

The most significant generative moment in Ailsa's art-collecting career was the acquisition in 1955 of the Edward Molyneux collection of impressionist and post-impressionist paintings. Born in London in 1891, Molyneux was a couturier who made his name in

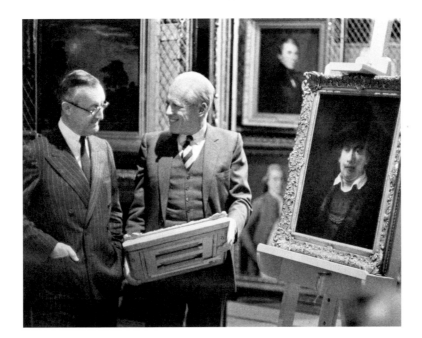

Figure 4
National Gallery of Art president Paul Mellon (left) and director John Walker (right), January 1967, National Gallery of Art, Gallery Archives

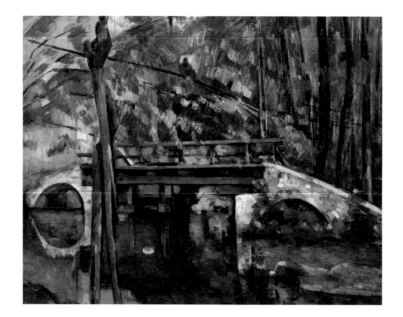

Figure 5
Paul Cézanne, *Pont de Maincy*, 1879, oil on canvas,
Musée d'Orsay, Paris

Paris and by the early 1920s had established the largest couture business in the world.
His fashion house, bearing his name, remained successful for thirty years.[15] He began
collecting art to decorate his apartment on quai d'Orsay, with an interest in eighteenth-
century French paintings. By the mid-1930s, however, he was focusing exclusively on
impressionist and post-impressionist paintings, often dealing directly with artists'
families. Many of his works by Édouard Vuillard, including *The Yellow Curtain* (pl. 61)
and *The Conversation* (pl. 60), came straight from the artist's studio. He acquired
Auguste Renoir's *Madame Monet and Her Son* (pl. 39) — a souvenir from the summer of
1874 when the two artists painted together in Petit-Gennevilliers — as well as Claude
Monet's *Bazille and Camille (Study for "Déjeuner sur l'herbe")* directly from Monet's second
son, Michel. Berthe Morisot's *Artist's Sister at a Window* (pl. 34) came from Morisot's
son-in-law, Ernest Rouart. Molyneux bought Alfred Sisley's marvelous, muted *Boulevard
Héloïse, Argenteuil* (pl. 5) and one of Georges Seurat's many studies for his epic master-
piece *La Grande Jatte* (pl. 25) from Wildenstein & Company, Paris; Eugène Boudin's *Beach
at Trouville* (pl. 9) through Arthur Tooth & Sons in London; Pierre Bonnard's *Cab Horse*
(pl. 53) and *Two Dogs in a Deserted Street* (pl. 55) from Bernheim-Jeune; and Monet's *Ships
Riding on the Seine* from Alex Reid & Lefevre in London. Half of the Renoirs came from
his dealer Ambroise Vollard, who had encouraged the artist to continue painting well
into his seventies. The Molyneux collection included a group of the small, insubstantial
daubs that remained in Renoir's studio at his death, dozens of which were unloaded
by Vollard on his clients.

Walker and Finley visited Molyneux in the fall of 1950 and a few months later,
through Ailsa's ex-husband, now the U.S. ambassador to France, Molyneux offered to
lend the Gallery his collection as a long-term loan. Securing the French export licenses
took some time, but in March 1952 the exhibition opened at the Gallery and then trav-
eled to the Museum of Modern Art (MoMA). As to Molyneux's motives in these events,
without direct heirs and living in an adopted homeland, he may have planned to sell
the collection. The Gallery and MoMA each had the collection essentially "on approval."
In his rather poetic preface to the 1952 exhibition catalogue, Walker describes Moly-
neux's avoidance of official pictures: "Seeking, instead, the personal flash of inspiration,
he has found works of unexpected and spontaneous beauty. He has been especially
attracted to paintings which convey with romantic intensity the deliciousness of life
before the first World War."[16]

The following year, the Gallery courted a collection of similar material, Edward G. Robinson's French modernist paintings. The great masterpiece of the Hollywood actor's collection was Paul Cézanne's *Black Clock*, around which were arrayed the same canonical masters as those found in Molyneux's collection, with pictures such as Jean-Baptiste-Camille Corot's *L'Italienne*, the Seurat *Le Crotoy*, one of the three versions of Vincent van Gogh's *Père Tanguy*, and smaller works by Bonnard, Vuillard, Henri de Toulouse-Lautrec, Boudin, early Henri Matisse, and the impressionists.[17] The Gallery may have considered buying the collection, or hoped he would give it, but a few years later, in 1957, it sold to Stavros Niarchos for $2.5 million.

At some point in the early 1950s Finley and Walker decided to ask Ailsa to buy the Molyneux collection, enjoy it during her lifetime, and ultimately give it to the Gallery. Over the spring and summer of 1955, Ailsa and Lauder Greenway met with Molyneux to discuss the acquisition. Finley negotiated the deal back in Paris, and in July, Ailsa paid $950,000 for seventy-three paintings. Among the greatest canvases in the collection, alas — Cézanne's *Pont de Maincy* (fig. 5) — was pulled from the list and sold to the French national museums as a condition for attaining an export license. Finley felt that the National Gallery of Art had other important Cézannes, namely the Dale pictures (which he hoped would come to the Gallery) and Charles Loeser's pictures (which had been given to the nation before the Gallery's founding). It could be sacrificed in favor of the Louvre, he felt, which had nothing from this moment of the artist's career.[18] The picture now hangs with the French national collection in the Musée d'Orsay.

Ailsa's Additions

The acquisition of the Molyneux paintings gave Ailsa a core group of works and further invested her in an area of collecting that was quite fashionable. In 1960 she loaned the collection to the Palace of the Legion of Honor in San Francisco, which like the Gallery had also hosted the Edward G. Robinson collection. She was clear with the director, Thomas Howe, that Molyneux should get the lion's share of the credit.[19] Avoiding the spotlight, she did not attend the opening.

In the years that followed, however, she became increasingly committed to molding the collection into something with more of her imprint. She may have been inspired by the San Francisco exhibition, by John Walker and the prospect of leaving to the nation a collection with her personal taste, and perhaps by Chester Dale's dismissive rumblings about the Molyneux collection and his prejudice against small paintings in general being "not of museum quality."[20]

Ailsa ultimately succeeded in building a collection of impressionist and post-impressionist paintings with a distinct flavor and a consistent level of quality. Her brother credited her with "very good taste"[21] and John Walker praised her "good eye."[22] She had the makings of a successful collector: the financial means, of course, but also the experience of looking at European pictures. According to Walker, she was also competitive. She grew up with her father's collection, spent summers in Europe as a child and traveled there regularly as a young adult, lived in New York City, and met regularly with dealers. When her cousin from Pittsburgh, Sarah Mellon Scaife, sought her art advice in the early 1860s, Ailsa accompanied her to auctions in Manhattan and helped her build the smaller but similar collection of impressionist and post-impressionist paintings that currently hangs at the Carnegie Museum of Art.

Working with Sam Salz, Wildenstein & Company, and Carroll Carstairs at Knoedler's (the son of Charles Carstairs, with whom Andrew had worked so closely), Ailsa acquired a total of five paintings by Camille Pissarro. Her early acquisition of Pissarro's *Place du Carrousel, Paris* (fig. 6) might have initiated the artist's special appeal for her. This sunlit summer view, painted from a rented room on the rue de Rivoli, of the entrance to the Tuileries garden with the Louvre on the left, was from Pissarro's successful series of Pari-

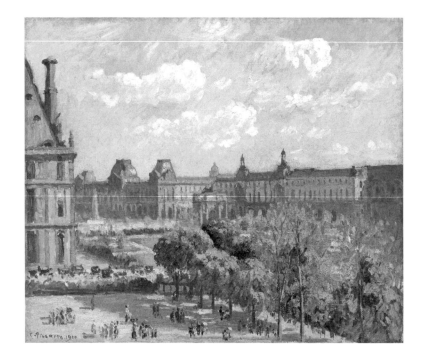

Figure 6
Camille Pissarro, *Place du Carrousel, Paris*, 1900,
oil on canvas, National Gallery of Art, Ailsa Mellon
Bruce Collection

sian cityscapes from the late 1890s. In 1965 Ailsa bought *Orchard in Bloom, Louveciennes* (pl. 4), an early work painted the year Pissarro was tutoring Cézanne in outdoor painting and two years before the first impressionist exhibition. This square painting, with its carefully calibrated pastel tones, celebrates the freshness of spring while it subtly employs the kind of solid compositional structure (the placement of the trees, the path, and the figures) that would preoccupy Cézanne throughout his career.

The impressionists' embrace of the clean, clear breeze of the French countryside is also found in Sisley's *Meadow* (pl. 7), a quickly painted capture of waving tall grasses and flowers, undulating fencing, and cloud-studded sky. Ailsa acquired it in 1957 by trading in Pissarro's *Route de Louveciennes* from the Molyneux collection. The deal involved an additional cash payment, worked out with Louis Goldenberg at Wildenstein's and the help of John Walker.

Four years later, Wildenstein's offered Ailsa what would be her most spectacular impressionist painting, Monet's *Artist's Garden at Vétheuil* (fig. 7). Here Monet used an unusual vertical format to depict his home garden in a Parisian suburb. Sunflowers and gladioli clamor around a garden path where children from his household play. In the 1950s and 1960s Ailsa's brother had also begun to collect impressionist paintings, inspired in part by his second wife, Rachel Lloyd. "Bunny," as she is known, was knowledgeable about nineteenth-century French paintings and the couple avidly began collecting in this area. They too were offered Monet's great Vétheuil canvas and were keenly interested, particularly given Bunny's expertise as a gardener. Jay Rousuck at Wildenstein's told them that Ailsa had it on reserve. Paul remembers advising the dealer *not* to share his interest in the painting with Ailsa, which in Paul's view would compel her to buy it.[23] One can imagine that this is precisely what the dealer did to close the sale, making this a telling tale about both sibling competition in the art market and the exploitation of such rivalry by the dealers.

To Ailsa, Wildenstein's also sold Monet's *Argenteuil* (pl. 2), another early impressionist painting in which the composition is set firmly in place, the horizon line forming a neat perpendicular with the towpath and line of trees, while the painter focused on recording the suffused radiance of a late afternoon in summer. Ailsa also bought a second Manet painting from Wildenstein's, *A King Charles Spaniel* (pl. 42), a charming portrait of a

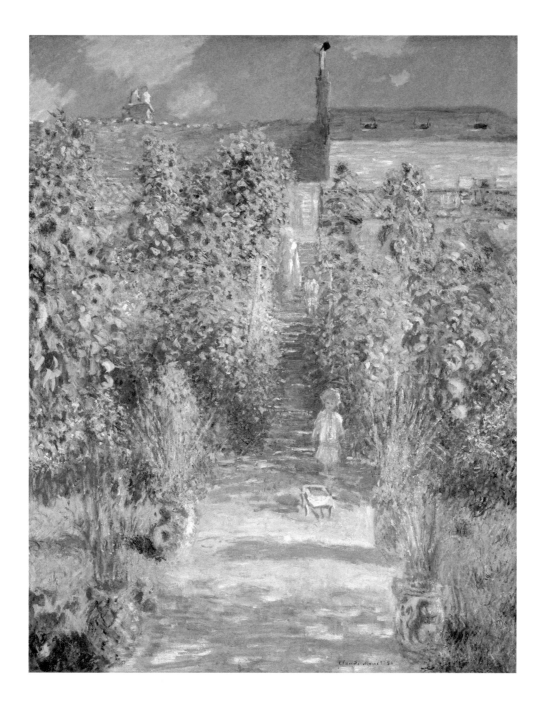

Figure 7
Claude Monet, *The Artist's Garden at Vétheuil*, 1880,
oil on canvas, National Gallery of Art, Ailsa Mellon
Bruce Collection

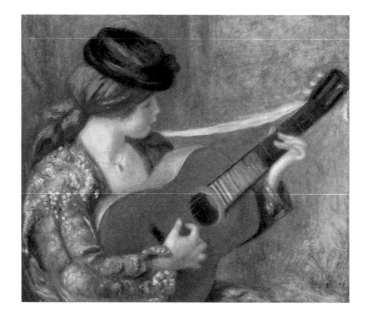

furry-faced pet of the breed favored by the English aristocracy. The picture was one of a series of canine paintings Manet produced but the only one he exhibited publicly. Employing a skilled but loose brushwork, the artist has captured the distinct character of this animal sitting regally on a velvet cushion, as well as the glossy texture of its fur.

Ailsa upgraded the group of Molyneux Renoirs with *Young Spanish Woman with a Guitar* (fig. 8), which she bought in 1962 from Sam Salz. Enchanted by his model wearing a richly embroidered bolero jacket, Renoir played the glittering warm colors of the musician's sleeve against her flesh tones and the striking red and black of her headgear, harmonizing the whole composition into a musical ode to Spanish exoticism.

Drawn to the kind of classic impressionist picture that celebrates color, sensuality, and pleasure, Ailsa seemed not to favor Edgar Degas, whose subject matter — unlike that of most of his impressionist colleagues — could be rather dark. In 1960 she was offered one of the paintings from Degas's melancholic visit to his family in New Orleans from 1872 to 1873, during which he created so many of his moving pictures of depressed Victorian-era women. *La Garde-Malade* depicts a sick-nurse waiting on an unseen patient in a tight, obscure hallway.[24] John Walker loved this marvelous gouache but returned it to Marianne Feilchenfeld in Zurich, "heartbroken" that Ailsa did not want it. He should not have been surprised, however, given the dark, medically ominous subject matter.

It is equally possible that Ailsa avoided Degas knowing that her brother had that artist covered in spades. She gave the Molyneux *Les Cavaliers*, a horizontally formatted painting of a line of racehorses, to her brother. She did, however, buy pictures by another of Paul's favorites, Eugène Boudin — among them the dazzling, flag-fluttering *Yacht Basin at Trouville-Deauville* (pl. 15). Her six paintings by the artist join Paul Mellon's twelve to form the largest collection of Boudins in the United States. Ailsa also bought Cézanne's *Riverbank* (fig. 9), despite her brother having acquired one of the artist's masterpieces, *Boy in a Red Waistcoat*, five years earlier. Perhaps she intended this daring, nearly abstract twentieth-century picture to compensate for the "lost" *Pont de Maincy*.

Among the richest moments in the Molyneux collection is the group of paintings by Bonnard and Vuillard. Ailsa added only one Vuillard to the ten acquired from Molyneux, the marvelous *Artist's Paint Box and Moss Roses* (pl. 63) for which she paid dearly.[25] As for Bonnard, however, she embarked on a small spree in the 1960s when, mostly from Wildenstein's, she bought great twentieth-century Bonnards, enhancing the group of 1890s Nabi pictures acquired by Molyneux. *The Green Table* (pl. 65), *Table Set in a*

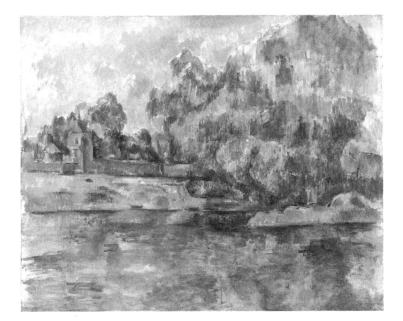

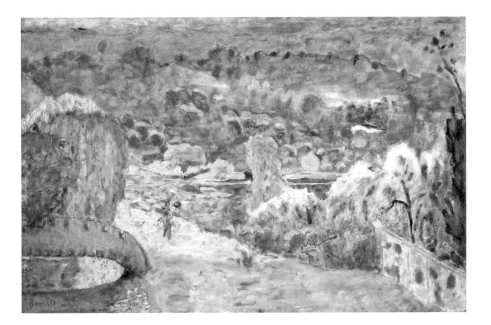

Garden (pl. 66), *Stairs in the Artist's Garden* (pl. 68), and *A Spring Landscape* (fig. 10) display Bonnard's radical experiments in sumptuous, psychedelic color.

These are paintings that could transform interiors into shining souvenirs of the lush spring-and-summer countryside, of flowers and foliage in the sunlight. Ailsa kept most of them in her New York apartment; some lived in her Syosset mansion, some in her Palm Beach home. She also owned two houses in Greenwich. There was plenty of space for an expanding collection.

In 1965 she bought a new apartment at 960 Fifth Avenue and, with the help of John Walker, spent over a year organizing the installation of her French pictures. Walker addressed the project as he would an exhibition at the Gallery, with maquette reproductions of the paintings and elevations of each room. During the construction, which Walker supervised personally down to tipping the art handlers, Ailsa's pictures were lent to the Gallery alongside her brother's for the exhibition *French Paintings from the Collections of Mr. and Mrs. Paul Mellon and Mrs. Mellon Bruce*, a celebration of the twenty-fifth anniversary of the National Gallery of Art. She helped select the paintings for

inclusion but did not attend the opening. The introduction for the catalogue was written by impressionism scholar John Rewald, who discussed the pleasures involved in collecting pictures of a smaller scale and cited the Molyneux collection's "emphasis on small canvases of exquisite charm and unusual mastery."[26]

Old Masters

At the same time that Ailsa was building a personal collection of French modernism, she was helping to build the Gallery's old master collection at an extremely ambitious level. The old master paintings she funded ranged from medium to very large in scale. Once acquired, they went directly to the Gallery.

Among the most spectacular objects that she did fleetingly consider keeping for herself was Jean-Honoré Fragonard's gorgeous confection *Young Girl Reading* (fig. 11). In this work, the eighteenth-century master's brush conveys — in candy-colored hues of yellow, pink, mauve, and red — a palette and painterly virtuosity that directly inspired Renoir a century later. Ailsa loved this image of a lovely young woman dressed in a ruff, contemplating a small text gracefully held in one hand, and she paid a record amount for it in 1961. The newspapers made much of the $800,000 price tag. While the sensational sale might have influenced her decision not to bring the canvas home to her New York apartment, both John Walker and Paul Mellon credited her memory of Reynolds' *Lady Caroline Howard*, and her father's stern lesson of the difference between public and private pictures, for the decision: some paintings are too important for private delectation. The credit line on the Fragonard reads, "Gift of Mrs. Mellon Bruce in memory of her father, Andrew W. Mellon."

John Walker appreciated her sacrifice, and attempted to assuage her sense of loss in an account he shared with her of President John F. Kennedy coming by to see the picture at the end of 1961: "'Our candidate,' as Paul calls the President, who was certainly Bunny's candidate, came to the Gallery to see it and was enraptured. He admitted she was the most enchanting young lady he had ever seen, and he is a very good judge!"[27]

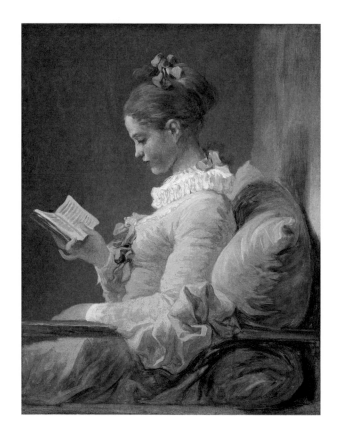

Figure 11
Jean-Honoré Fragonard, *Young Girl Reading*,
c. 1770, oil on canvas, National Gallery of Art,
Gift of Mrs. Mellon Bruce in memory of her father,
Andrew W. Mellon

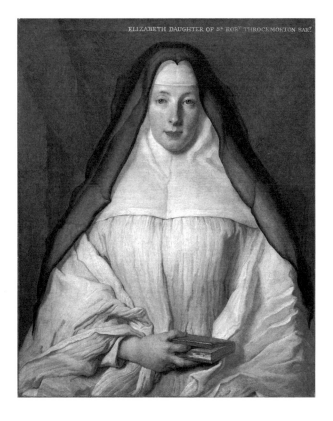

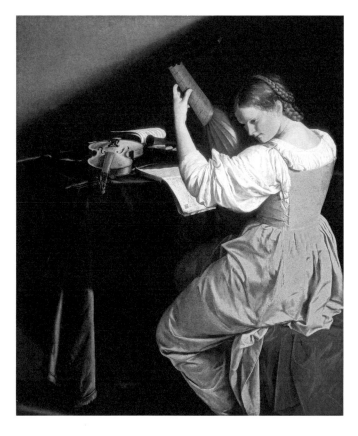

Figure 12
Nicolas de Largillierre, *Elizabeth Throckmorton,
Canoness of the Order of the Dames Augustines
Anglaises*, 1729, oil on canvas, National Gallery
of Art, Ailsa Mellon Bruce Fund

Figure 13
Orazio Gentileschi, *The Lute Player*, c. 1612/1620,
oil on canvas, National Gallery of Art, Ailsa
Mellon Bruce Fund

Given his training and experience with old master paintings, and his vision of the
future of the National Gallery of Art, Walker consistently presented to Ailsa for consideration paintings of high quality and art-historical significance. Many of them, like the
Fragonard, involve images of women in contemplative, spiritual, or self-presentational
modes. Such is the case with Nicolas de Largillierre's ethereal portrait of Elizabeth
Throckmorton (fig. 12), canoness of an order of English Catholic nuns in Paris; Francisco
de Goya's *Condesa de Chinchón*, a painting (like the Reynolds) of an aristocratic girl
whose youthful naïveté shines through the strictures of formal portraiture; two images
of the Assumption of the Virgin — one circa 1500 by the Fleming Michel Sittow, the
other early seventeenth century by French painter Nicolas Poussin; Orazio Gentileschi's
Caravaggesque female *Lute Player* (fig. 13); Ercole de' Roberti's *Wife of Hasdrubal and Her
Children;* and, most spectacularly, Leonardo da Vinci's luminous portrait of another
wealthy banker's daughter, *Ginevra de' Benci* (fig. 14).

The funds to acquire these great masterpieces — the Leonardo, as the only painting
by the master in North America, is perhaps the Gallery's most famous painting — were
organized in 1962 as the Ailsa Mellon Bruce Fund, established to expand the Gallery's
collection in significant ways.[28] Ailsa worked on each of these acquisitions with John
Walker, her friend Lauder Greenway often participating as an intermediary. Walker
estimated that Ailsa spent between $20 million and $30 million on paintings for the
Gallery.[29] Her help was key to the successful growth of the Gallery's collection over its
first several decades, maintaining the momentum set by the Kress, Widener, Rosenwald, and Dale gifts.

In a note to John Walker in 1968 thanking him for the presentation of an album of her gifts to the Gallery, she was characteristically demure: "It had never occurred to me to be thanked for anything concerning the National Gallery. It has always been my chief interest and pleasure to do for it what I could do."[30]

Ailsa's Legacy

Ailsa's precipitous decline and death in August 1969 caught many people by surprise. While she suffered bouts of illness throughout her life, the death of her daughter Audrey in 1967 might have further depleted her will. Carter Brown, the recently appointed Gallery director, quickly organized a memorial exhibition of fifty paintings, sculptures, and drawings acquired through her support. The show, which ran for a short six weeks, proved a significant (if brief) revelation. In addition to the paintings of women mentioned above, it included Murillo's *Return of the Prodigal Son*, Peter Paul Rubens' *Daniel in the Lions' Den*, Claude Lorrain's *Judgment of Paris*, Rogier van der Weyden's *Saint George and the Dragon*, and Giovanni Paolo Panini's *Interior of Saint Peter's, Rome*. Her gifts included major American paintings, among them the Thomas Cole *Voyage of Life* cycle, Winslow Homer's *Right and Left*, John Singleton Copley's *Epes Sargent*, and Jasper Francis Cropsey's *Autumn — On the Hudson River*. The press release quoted Carter Brown: "Over the years the fruits of Mrs. Bruce's quiet generosity have taken up their positions around our building according to their period and medium. To see them all together this way for the first time comes as a surprise even to those of us who work here."[31]

In his review of the memorial exhibition, *Sunday Star* critic Frank Getlein understood the singularity of Ailsa's beneficence. He wrote, "She was that most valuable of donors, the one concerned with the emerging of the museum's total collection rather than with her own identity within that emergence. A great deal of her time and her money were spent not on building up a collection in her own name in the gallery, but rather in helping the gallery director, the recently retired John Walker, to fill gaps and plug holes in the overall collection of the National Gallery. It is a function of cultural giving less likely to lead to personal glory than more conventional roles, but it is an essential function, which has played an important part in the still astonishing rise of the National Gallery to the front rank of world art museums in so short a time."[32]

The memorial exhibition, which had quickly gathered together paintings from galleries across the West Building, did not include Ailsa's collection of French impressionist and post-impressionist pictures. At her death, they still hung in her new New York apartment and in her several other homes. Once the paintings did arrive at the Gallery, the larger, more significant works made their way to the walls of the West Building, while the smaller paintings went into storage.

Matching her brother Paul's grant, Ailsa had committed $10 million toward the construction of a new building for the Gallery to house the expanding collection of modern and contemporary art, as well as staff offices, a scholars program, the library, and a large auditorium. This was an extraordinary gift for which she was posthumously honored during the 1978 opening of the East Building, where a suite of smaller galleries on the ground floor was dedicated to paintings from her collection. The initial installation was uneven in quality. A year before she died, likely at her request, John Walker and curator Perry Cott drew up a list of paintings and works on paper that the Gallery wanted from Ailsa's collection, and separate lists of pictures they did not want. The selections did not register in Ailsa's will before her death, however, and in the end everything came to the Gallery. The 1978 installation included the rejected works but not Ailsa's significant additions to the Molyneux collection — these were her most important French modernist paintings, which hung in the West Building but were not moved for the new installation. A catalogue recorded the installation, carrying the same title as the galleries: *Small French Paintings from the Bequest of Ailsa Mellon Bruce.* There is no full catalogue of her impressionist and post-impressionist collection, nor has there ever been a full installation. The sense of her achievement as a collector in this area is therefore often associated with the 1978 catalogue, and with the galleries that have retained her name. Combined with the absence of a catalogue for the 1969 memorial exhibition, and above all because Ailsa so rigorously avoided credit, the nature and extent of her patronage is not widely known.

Ailsa's achievement follows a successful formula specific to American cultural institutions: a partnership between an art patron of great financial means and an enlightened attitude of civic generosity on the one hand, and an art historian and gifted museum professional with a clear vision on the other. At the end of 1966, less than three years before Ailsa's death and his own retirement, John Walker himself wrote:

> It is difficult to know how to thank you for your generosity to the Gallery. Perhaps if I told you that your support has meant more to me than anything else that has occurred in my professional life this might convey some idea of how much I appreciate what you have done. I hope it gives you some satisfaction to know that your father, I feel sure, would be pleased with the first twenty-five years of the institution he established. You, more than anyone else, have made possible its growth and future development.[33]

Notes

I would like to thank Maygene Daniels, chief of the National Gallery of Art Gallery Archives, for guiding me through the Mellon literature, the archives, and several crucial points in earlier drafts of this essay. I am grateful to Jean Henry as well for her patient assistance in making archival material available and for suggesting further sources.

1 David Cannadine, *Mellon: An American Life* (New York, 2008), 261, 456.

2 Paul Mellon, oral history interview by Robert Bowen, July 26–27 and November 10, 1988, transcript, 51. National Gallery of Art, Gallery Archives.

3 On this picture, see John Hayes, *British Paintings of the Sixteenth through Nineteenth Centuries*, National Gallery of Art Systematic Catalogue (Washington, 1992), 218.

4 Mellon, interview, 50.

5 John Walker's opening line on his chapter-section on Ailsa: "If about Paul there is an aura of happiness, about his sister Ailsa, there was always one of sadness.... It was as though a wicked fairy had appeared at her christening, waved a wand, and blighted all future enjoyment of her wealth and beauty." John Walker, *Self-Portrait with Donors: Confessions of an Art Collector* (New York, 1974), 195. Sad themes were reiterated in Paul Mellon, *Reflections in a Silver Spoon* (New York, 1992), 379.

6 See Nelson D. Lankford, *The Last American Aristocrat: The Biography of Ambassador David K. E. Bruce, 1898 – 1977* (New York, 1996), 164 – 169 and 616.

7 Cannadine, 332.

8 Cannadine, 334.

9 Paul Mellon, "Remarks at Dinner for the Opening of the Ailsa Mellon Bruce Galleries," May 27, 1976, printed in *Carnegie Magazine*, November 1976, 408 – 411.

10 At several points in the 1988 interview, Robert Bowen guides him back to the subject, but Paul resists and moves on.

11 Audrey was class of 1952 at Foxcroft School in Middleburg, Virginia.

12 The files in the National Gallery of Art Gallery Archives detail Walker's correspondence with Ailsa. Donor files, Series 3A1, Box 1.

13 John Walker, oral history interview by Eric Lindquist, July 27, 1987, transcript, 21, 31. Gallery Archives.

14 John Walker to Ailsa Mellon Bruce, January 28, 1949. Gallery Archives, Donor files, Series 3A1, Box 1.

15 I am indebted to Nancy Yeide, National Gallery of Art head of curatorial records and files, for her unpublished research on Molyneux.

16 National Gallery of Art, *French Paintings from the Molyneux Collection* (Washington, 1952).

17 National Gallery of Art, *Forty Paintings from the Edward G. Robinson Collection* (Washington, 1953).

18 David Finley to Huntington Cairnes, July 20, 1955. Gallery Archives, Donor files, SG series, 4A11, Box 2.

19 Thomas Howe to R. G. White at Avalon Foundation, May 3, 1961: "Being also of the opinion that Mrs. Bruce would find 'gush' (for want of a better word) distasteful, I have refrained from encomiums of praise in which I might have otherwise indulged. I hope that my comments will meet with her approval." Gallery Archives, RG 3 A1, Box 1.

20 Mellon, *Reflections*, 271.

21 Mellon, interview, 52.

22 Burton Hersh, *The Mellon Family: A Fortune in History* (New York, 1978), 412.

23 Paul and Ailsa apparently also competed through Sam Salz for Pissarro's *Hampton Court*. Mellon, interview, 52.

24 Likely no. 314 in P. A. Lemoisne, *Degas et son oeuvre* (New York, 1984).

25 Bought from Wildenstein's in 1959. Gallery Archives, Series 3A1, Box 1.

26 National Gallery of Art, *French Paintings from the Collections of Mr. and Mrs. Paul Mellon and Mrs. Mellon Bruce: Twenty-fifth Anniversary Exhibition* (Washington, 1966), introduction.

27 John Walker to Ailsa Mellon Bruce, December 18, 1961. Gallery Archives, Donor files, Series 3A1, Box 1.

28 Called by the *New York Times* during the memorial exhibition "the most expensive painting in the world…the only undoubted Leonardo owned outside Europe." *New York Times,* September 1, 1969. It was bought from Prince of Liechtenstein Franz Josef II for more than $5 million.

29 Walker, interview, 21.

30 Ailsa Mellon Bruce to John Walker, May 25, 1968. Gallery Archives, Donor files, Series 3A1, Box 1.

31 National Gallery of Art press release, August 29, 1969. Gallery Archives.

32 Frank Getlein, *Sunday Star*, August 31, 1969.

33 John Walker to Ailsa Mellon Bruce, December 1, 1966. Gallery Archives, Donor files, Series 3A1, Box 1.

Plates

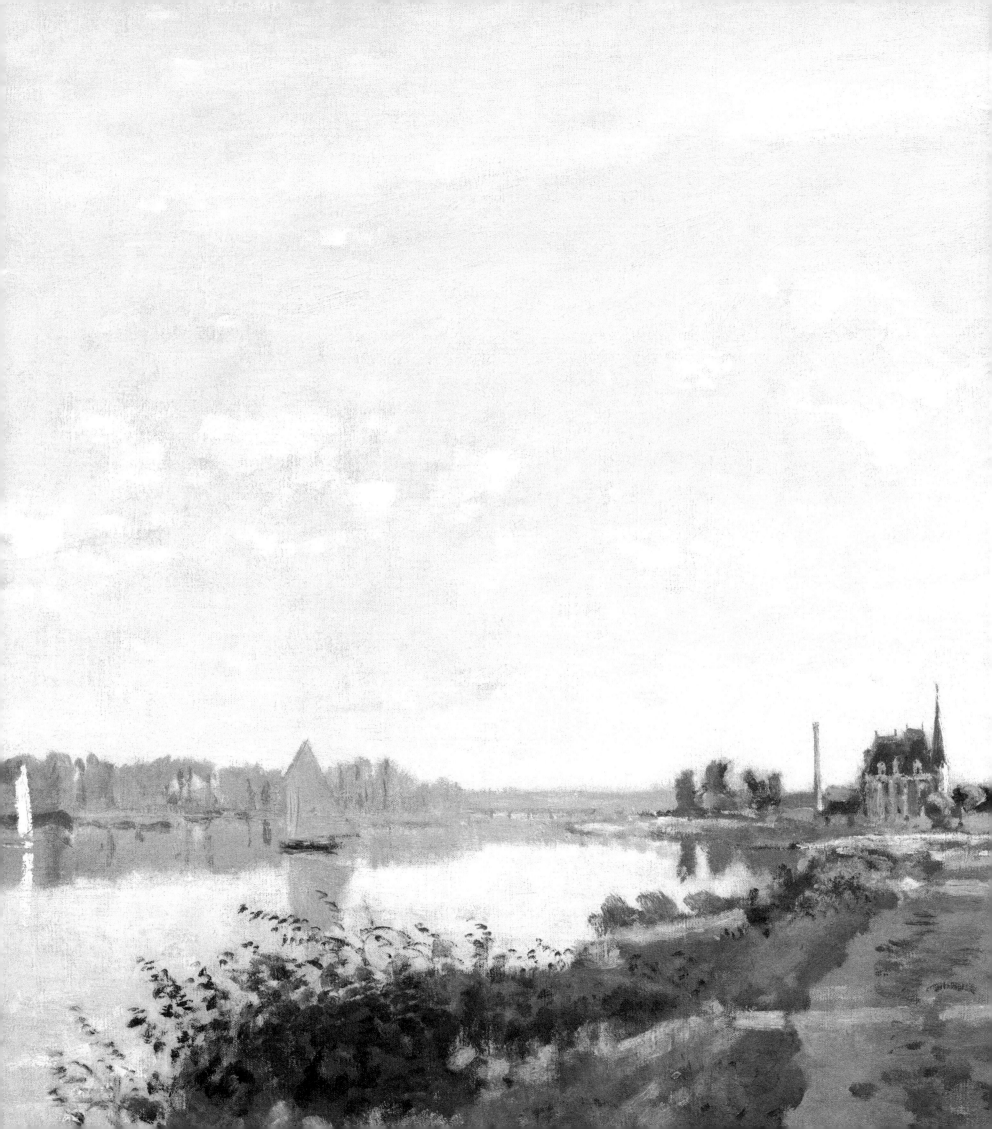

overleaf Claude Monet (pl. 2)

Plate 1
Johan Barthold Jongkind (Dutch, 1819 – 1891)
The Towpath, 1864
oil on canvas
34.3 × 47 cm (13 ½ × 18 ½ in.)
Collection of Mr. and Mrs. Paul Mellon

Plate 2
Claude Monet (French, 1840 – 1926)
Argenteuil, c. 1872
oil on canvas
50.4 × 65.2 cm (19 ¹³⁄₁₆ × 25 ¹¹⁄₁₆ in.)
Ailsa Mellon Bruce Collection

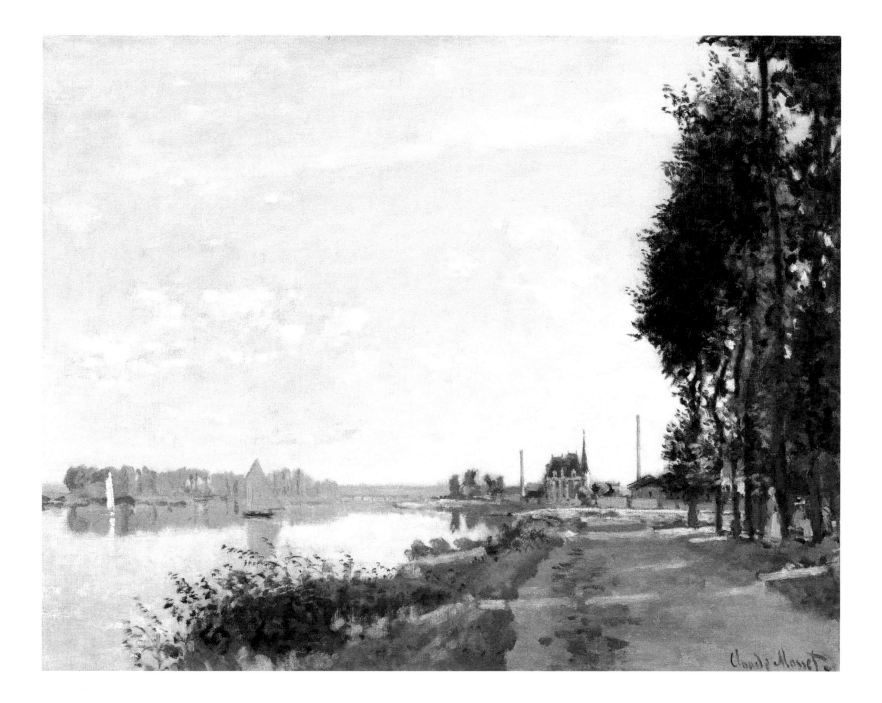

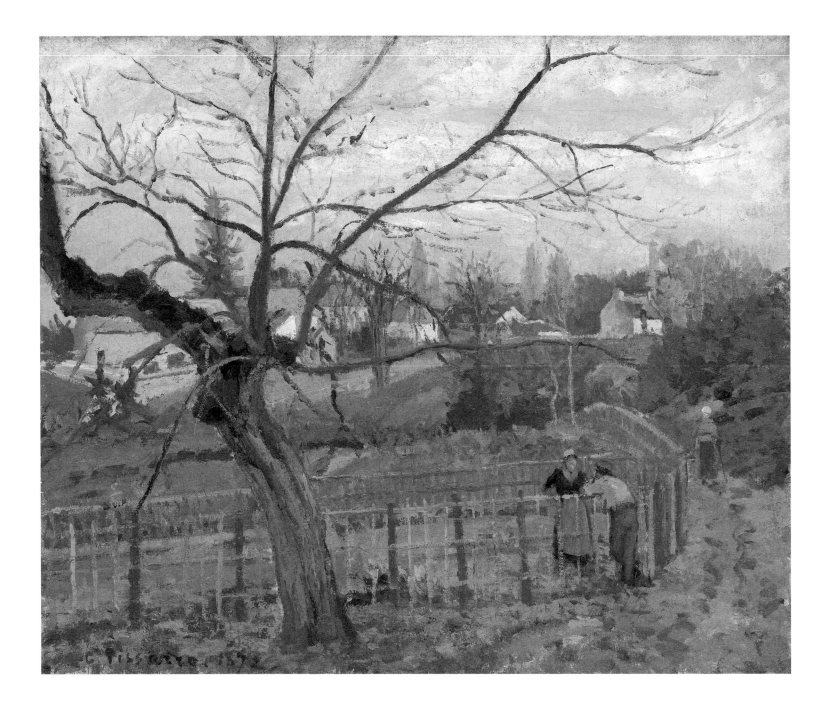

Plate 3
Camille Pissarro (French, 1830 – 1903)
The Fence, 1872
oil on canvas
37.8 × 45.7 cm (14 ⅞ × 18 in.)
Collection of Mr. and Mrs. Paul Mellon

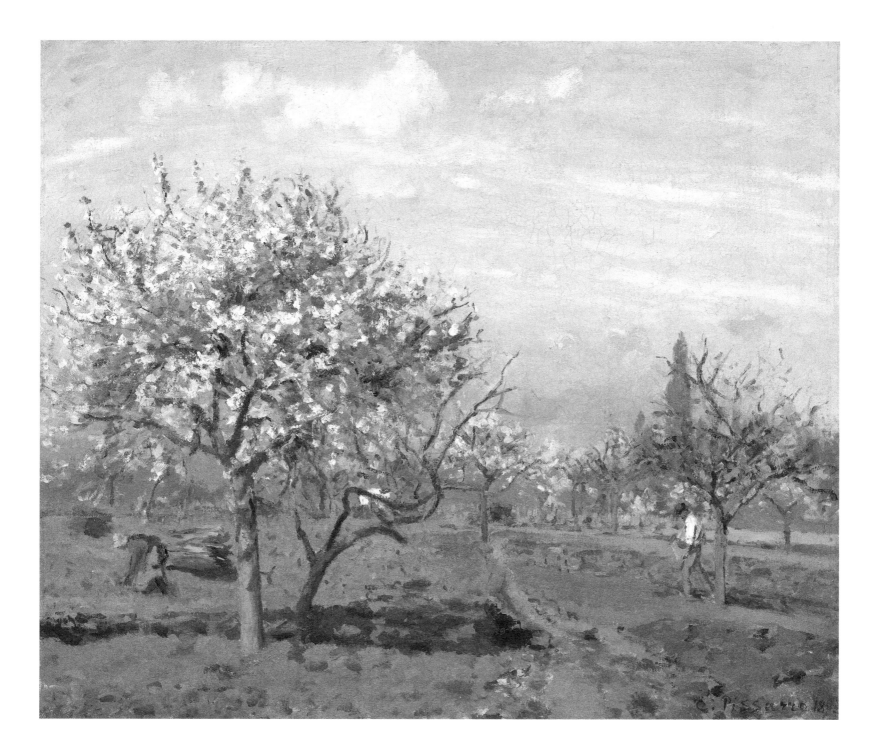

Plate 4
Camille Pissarro (French, 1830 – 1903)
Orchard in Bloom, Louveciennes, 1872
oil on canvas
45.1 × 54.9 cm (17 ¾ × 21 ⅝ in.)
Ailsa Mellon Bruce Collection

37

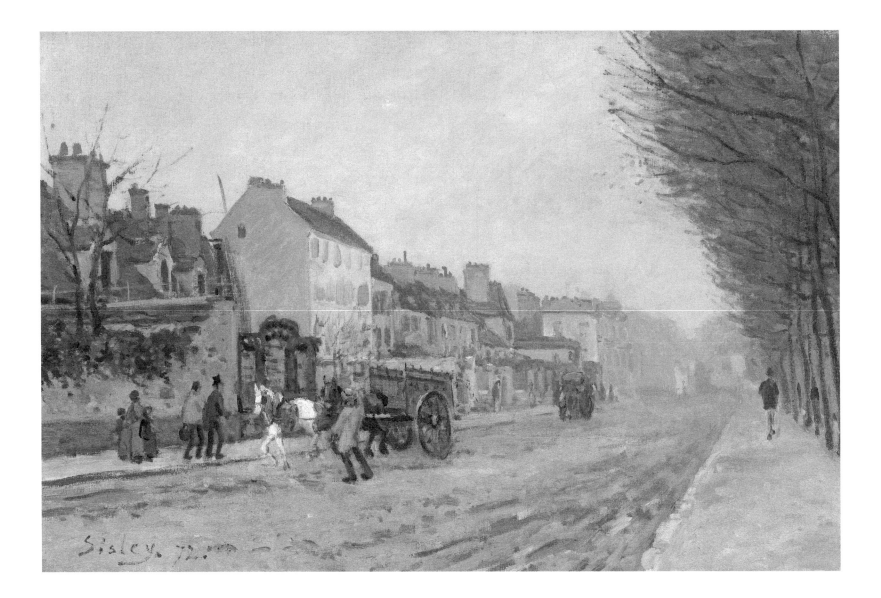

Plate 5
Alfred Sisley (French, 1839 – 1899)
Boulevard Héloïse, Argenteuil, 1872
oil on canvas
39.5 × 59.6 cm (15 ⁹⁄₁₆ × 23 ⁷⁄₁₆ in.)
Ailsa Mellon Bruce Collection

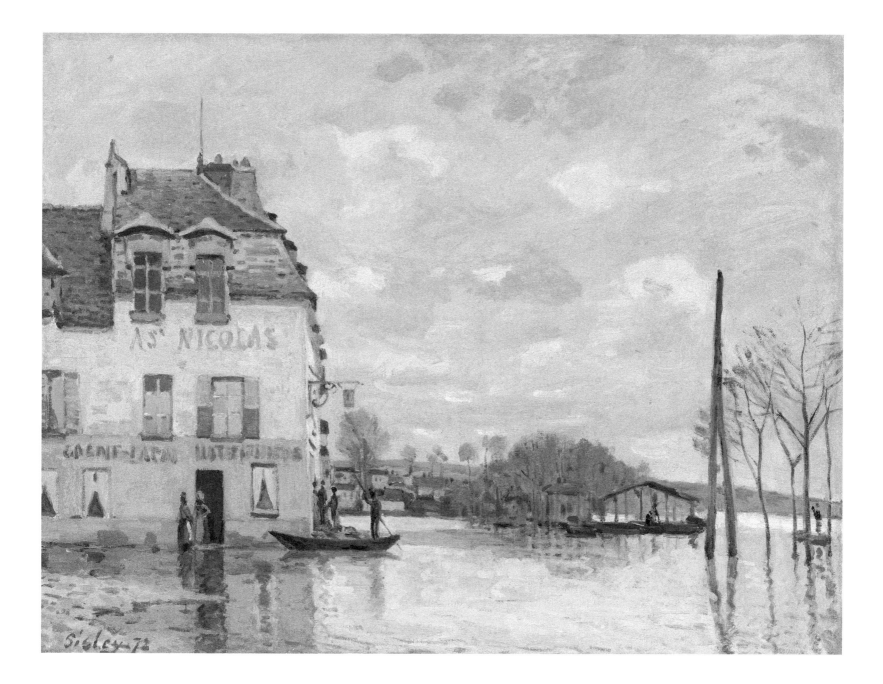

Plate 6
Alfred Sisley (French, 1839 – 1899)
Flood at Port-Marly, 1872
oil on canvas
46.4 × 61 cm (18 ¼ × 24 in.)
39 Collection of Mr. and Mrs. Paul Mellon

Plate 7
Alfred Sisley (French, 1839 – 1899)
Meadow, 1875
oil on canvas
54.9 × 73 cm (21 ⅝ × 28 ¾ in.)
Ailsa Mellon Bruce Collection

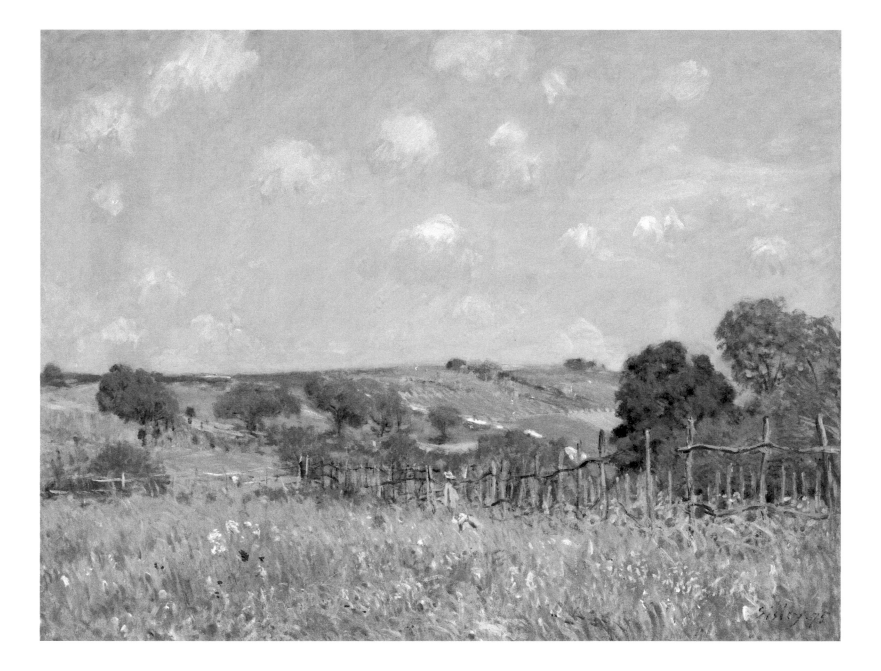

Plate 8
Eugène Boudin (French, 1824–1898)
Festival in the Harbor of Honfleur, 1858
oil on wood
41 × 59.3 cm (16 ⅛ × 23 ⅜ in.)
Collection of Mr. and Mrs. Paul Mellon

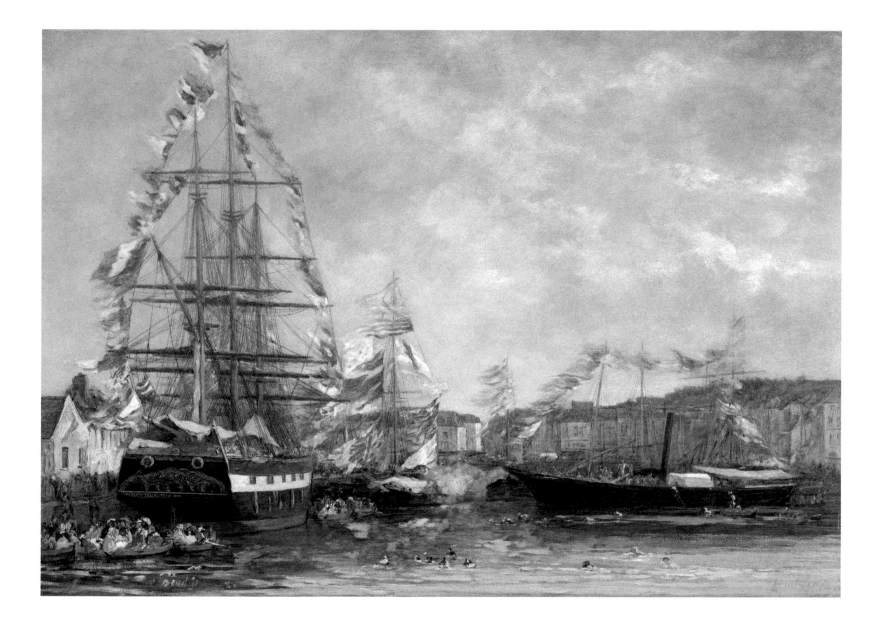

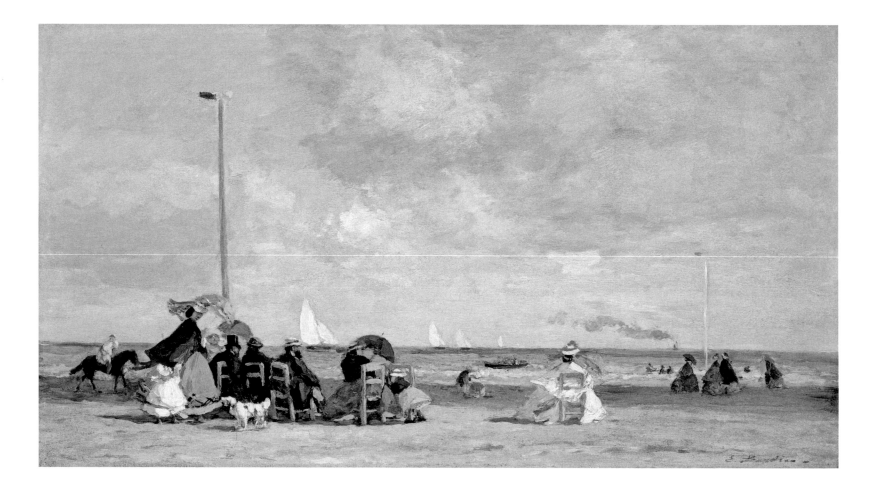

Plate 9
Eugène Boudin (French, 1824 – 1898)
Beach at Trouville, 1864/1865
oil on wood
27 × 49.1 cm (10 ⅝ × 19 ⁵⁄₁₆ in.)
44 Ailsa Mellon Bruce Collection

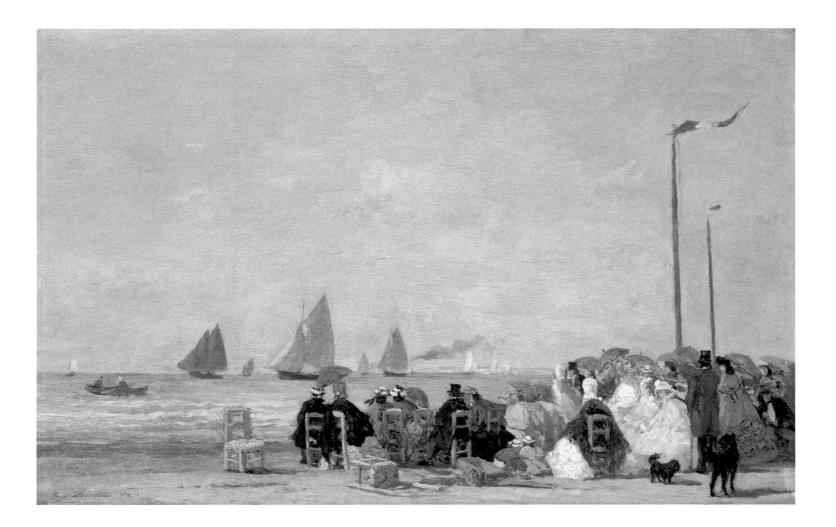

Plate 10
Eugène Boudin (French, 1824 – 1898)
Beach Scene at Trouville, 1863
oil on wood
34.8 × 57.5 cm (13 ¹¹⁄₁₆ × 22 ⅝ in.)
Collection of Mr. and Mrs. Paul Mellon

45

Plate 11
Eugène Boudin (French, 1824 – 1898)
Concert at the Casino of Deauville, 1865
oil on canvas
41.7 × 73 cm (16 $\frac{7}{16}$ × 28 $\frac{3}{4}$ in.)
Collection of Mr. and Mrs. Paul Mellon

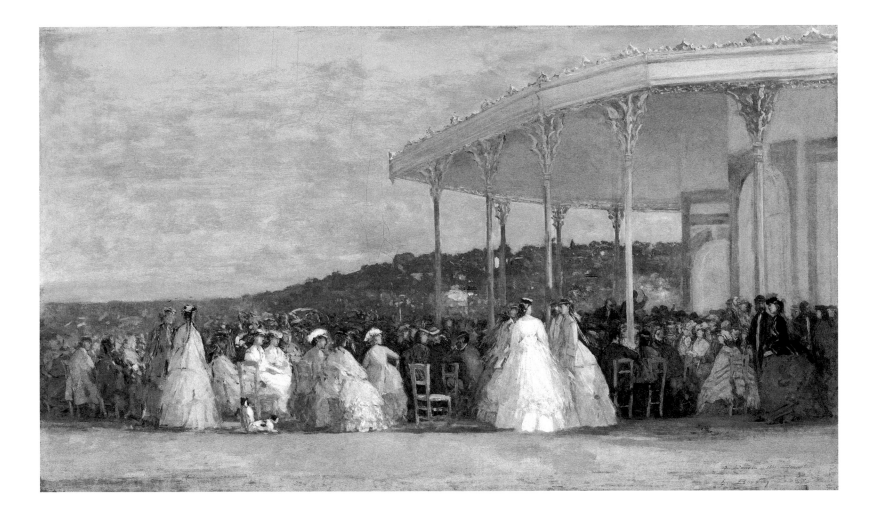

Plate 12
Eugène Boudin (French, 1824 – 1898)
Coast of Brittany, 1870
oil on canvas
47.3 × 66 cm (18 ⅝ × 26 in.)
Collection of Mr. and Mrs. Paul Mellon

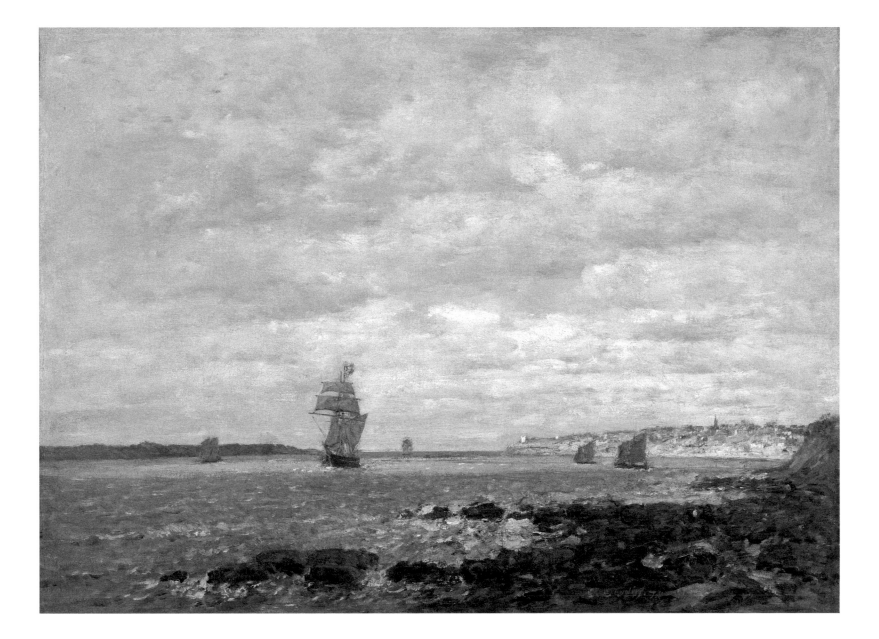

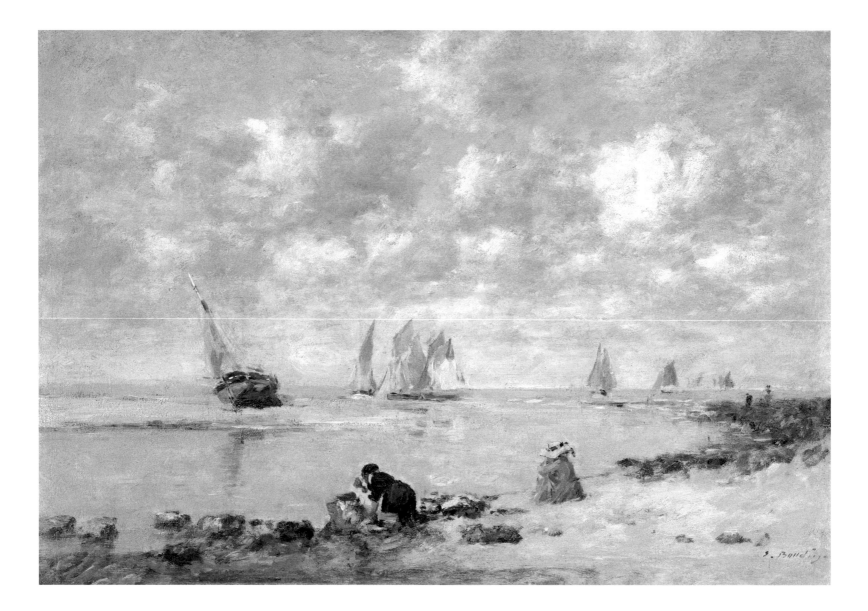

Plate 13
Eugène Boudin (French, 1824 – 1898)
Washerwoman near Trouville, c. 1872/1876
oil on wood
27.6 × 41.3 cm (10 ⅞ × 16 ¼ in.)
Collection of Mr. and Mrs. Paul Mellon

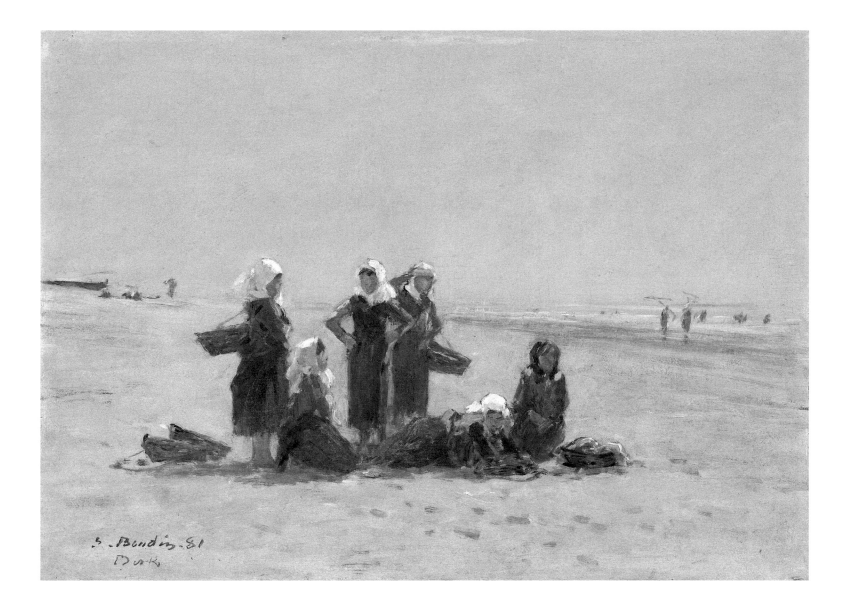

Plate 14
Eugène Boudin (French, 1824 – 1898)
Women on the Beach at Berck, 1881
oil on wood
24.8 × 36.2 cm (9 ¾ × 14 ¼ in.)
Ailsa Mellon Bruce Collection

Plate 15
Eugène Boudin (French, 1824 – 1898)
Yacht Basin at Trouville-Deauville, probably 1895/1896
oil on wood
45.8 × 37.1 cm (18 ¹⁄₁₆ × 14 ⅝ in.)
Ailsa Mellon Bruce Collection

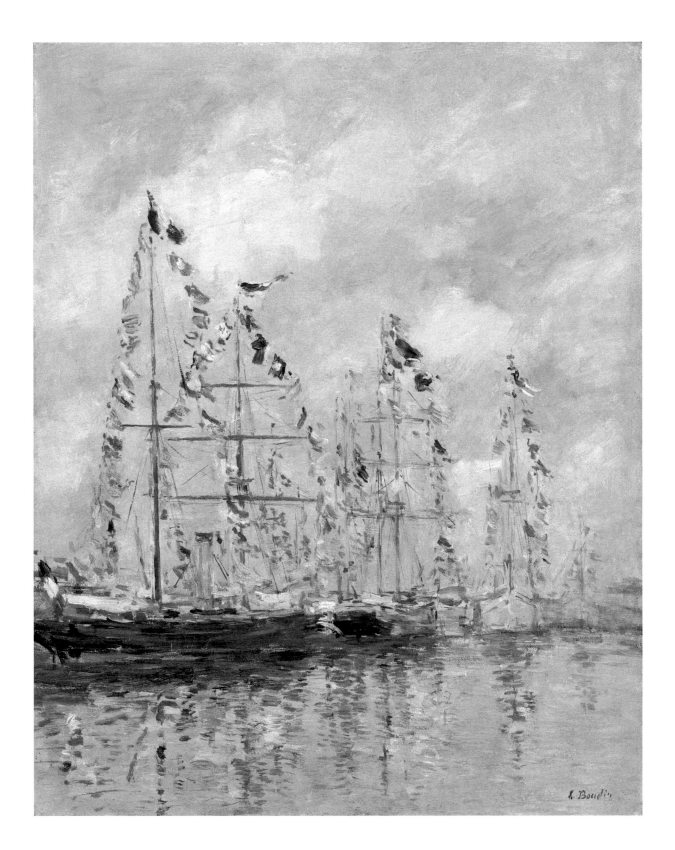

Plate 16
Auguste Renoir (French, 1841–1919)
Picking Flowers, 1875
oil on canvas
54.3 × 65.2 cm (21 ⅜ × 25 ¹¹⁄₁₆ in.)
Ailsa Mellon Bruce Collection

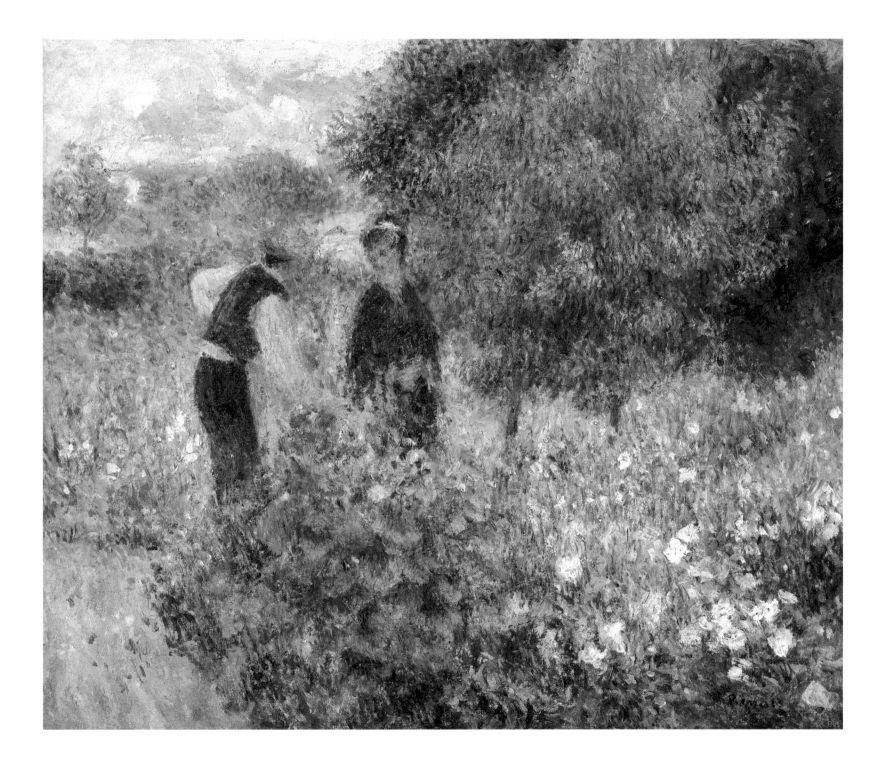

Plate 17
Auguste Renoir (French, 1841 – 1919)
The Vintagers, 1879
oil on canvas
54.2 × 65.4 cm (21 5/16 × 25 3/4 in.)
Gift of Margaret Seligman Lewisohn
in memory of her husband, Sam A. Lewisohn

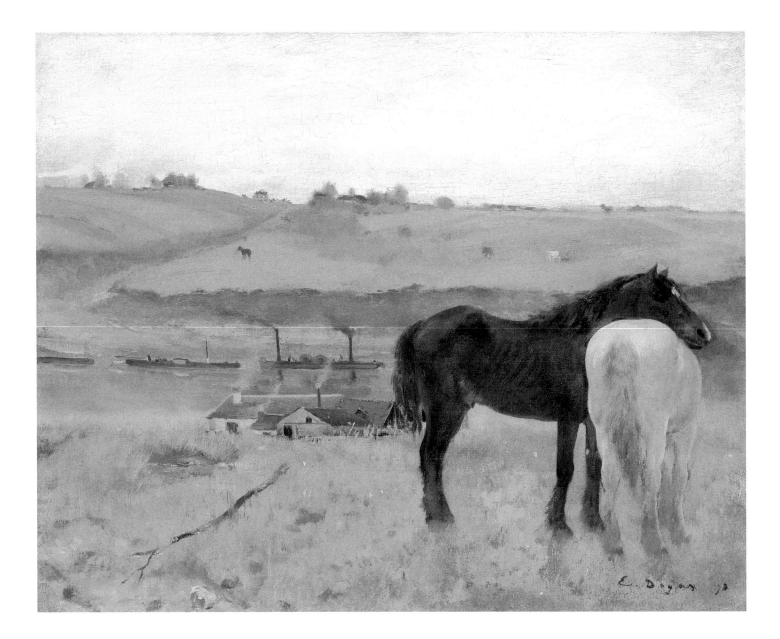

Plate 18
Edgar Degas (French, 1834 – 1917)
Horses in a Meadow, 1871
oil on canvas
31.8 × 40 cm (12 ½ × 15 ¼ in.)
Chester Dale Fund

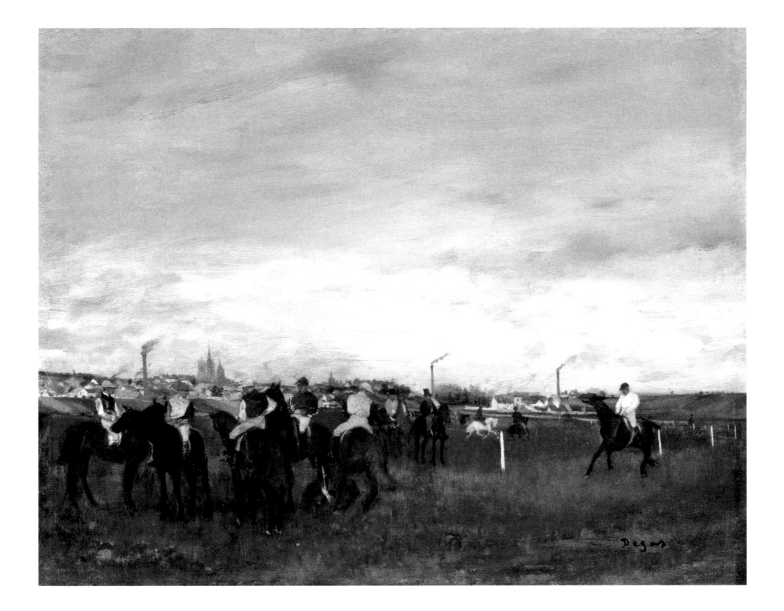

Plate 19
Edgar Degas (French, 1834 – 1917)
The Races, 1871 – 1872
oil on wood
26.6 × 35.1 cm (10 ½ × 13 ¹³⁄₁₆ in.)
Widener Collection

Plate 20
Édouard Manet (French, 1832 – 1883)
At the Races, c. 1875
oil on wood
12.6 × 21.9 cm (4 ¹⁵⁄₁₆ × 8 ⅝ in.)
Widener Collection

Plate 21
Paul Cézanne (French, 1839 – 1906)
The Battle of Love, c. 1880
oil on canvas
38 × 46 cm (14 $^{15}\!/_{16}$ × 18 $^{1}\!/_{8}$ in.)
Gift of the W. Averell Harriman Foundation
in memory of Marie N. Harriman

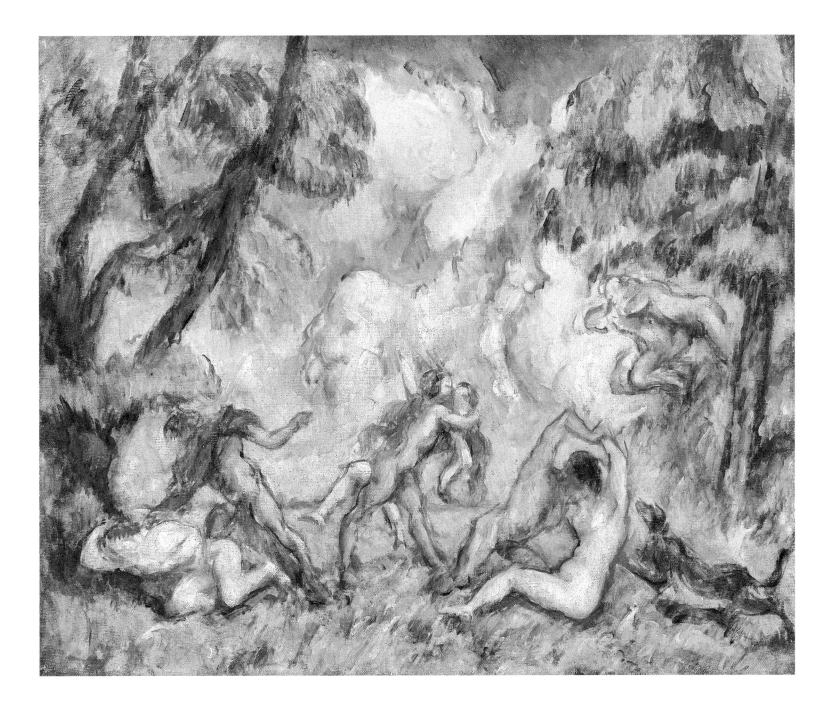

Plate 22
Vincent van Gogh (Dutch, 1853–1890)
Flower Beds in Holland, c. 1883
oil on canvas on wood
48.9 × 66 cm (19 ¼ × 26 in.)
Collection of Mr. and Mrs. Paul Mellon

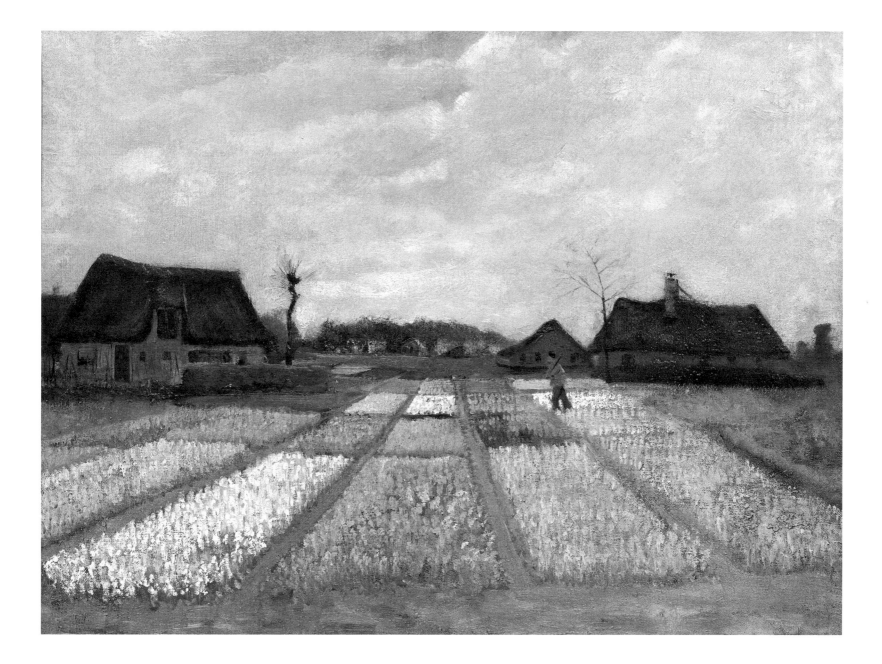

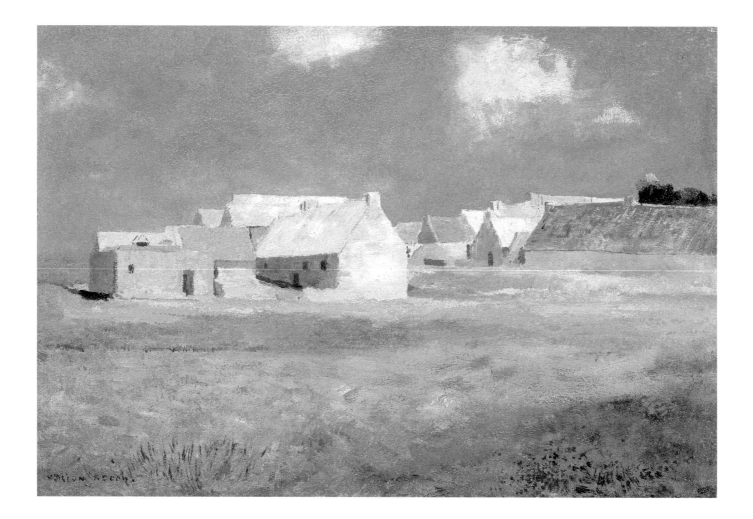

Plate 23
Odilon Redon (French, 1840 – 1916)
Breton Village, c. 1890
oil on canvas
22.5 × 32.5 cm (8 ⅞ × 12 ¹³⁄₁₆ in.)
Collection of Mr. and Mrs. Paul Mellon

66

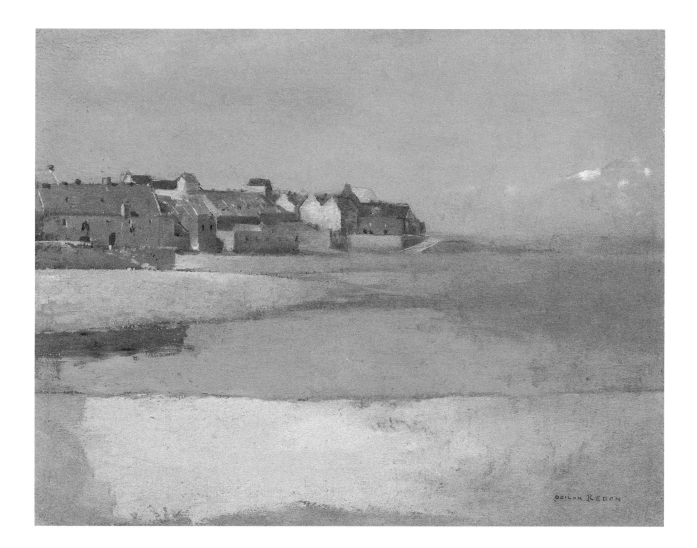

Plate 24
Odilon Redon (French, 1840 – 1916)
Village by the Sea in Brittany, c. 1880
oil on cardboard on hardboard
25.1 × 32.4 cm (9 ⅞ × 12 ¾ in.)
Collection of Mr. and Mrs. Paul Mellon

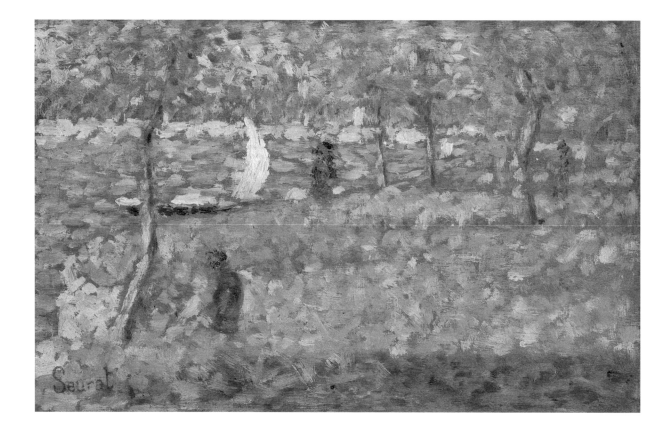

Plate 25
Georges Seurat (French, 1859 – 1891)
Study for "La Grande Jatte," 1884/1885
oil on wood
15.9 × 25 cm (6 ¼ × 9 ¹³⁄₁₆ in.)
Ailsa Mellon Bruce Collection

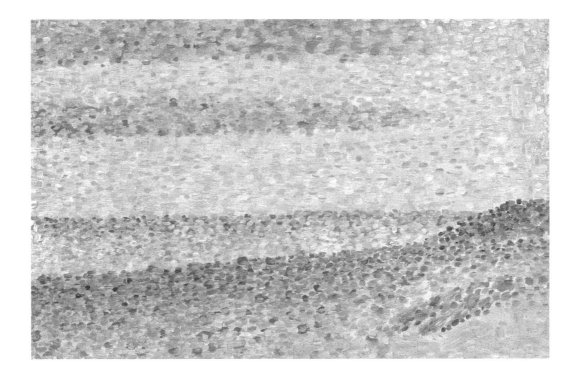

Plate 26
Georges Seurat (French, 1859 – 1891)
Seascape (Gravelines), 1890
oil on panel
16 × 25 cm (6 5/16 × 9 13/16 in.)
Collection of Mr. and Mrs. Paul Mellon

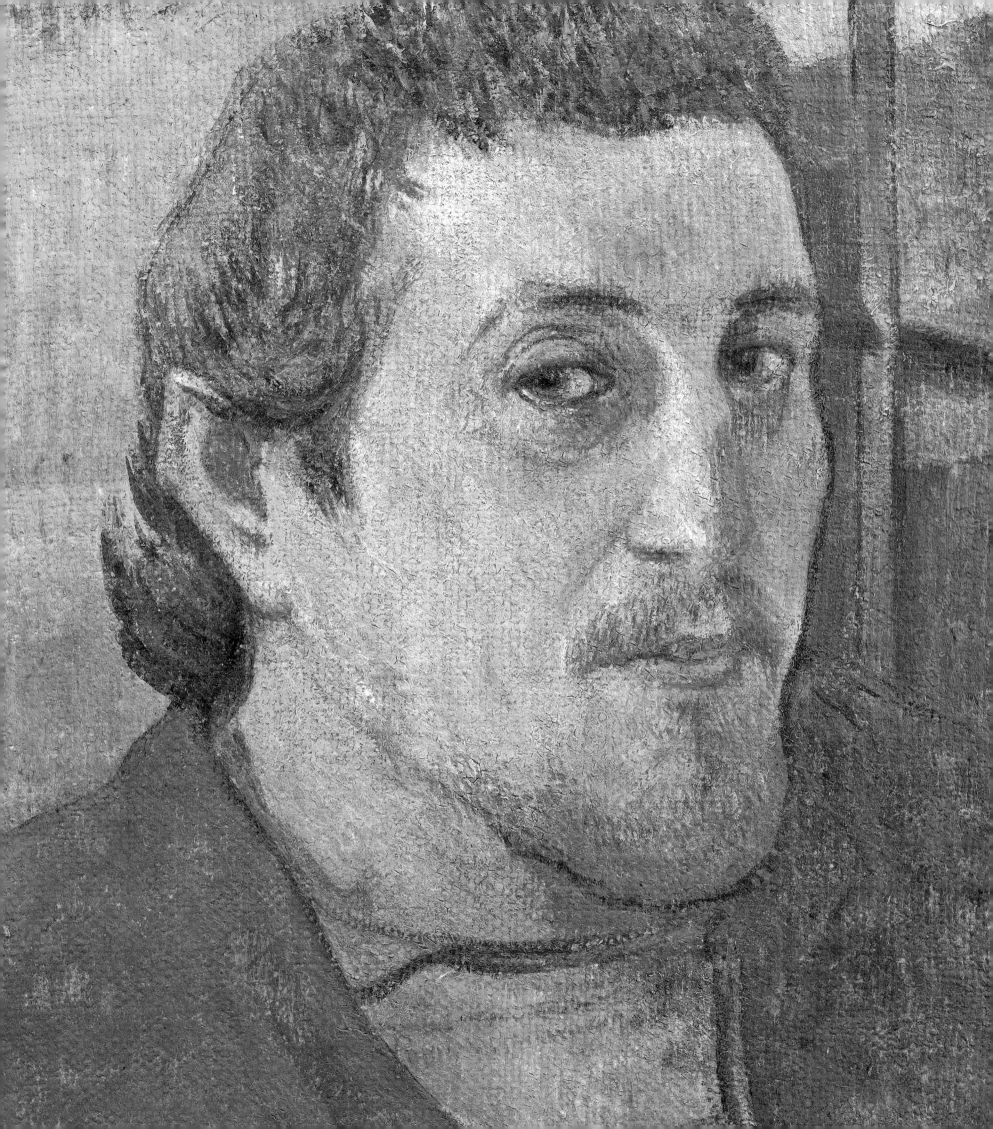

overleaf Paul Gauguin (pl. 32)

Plate 27
Henri Fantin-Latour (French, 1836 – 1904)
Self-Portrait, 1861
oil on canvas
25.1 × 21.4 cm (9 ⅞ × 8 ⁷⁄₁₆ in.)
Collection of Mr. and Mrs. Paul Mellon

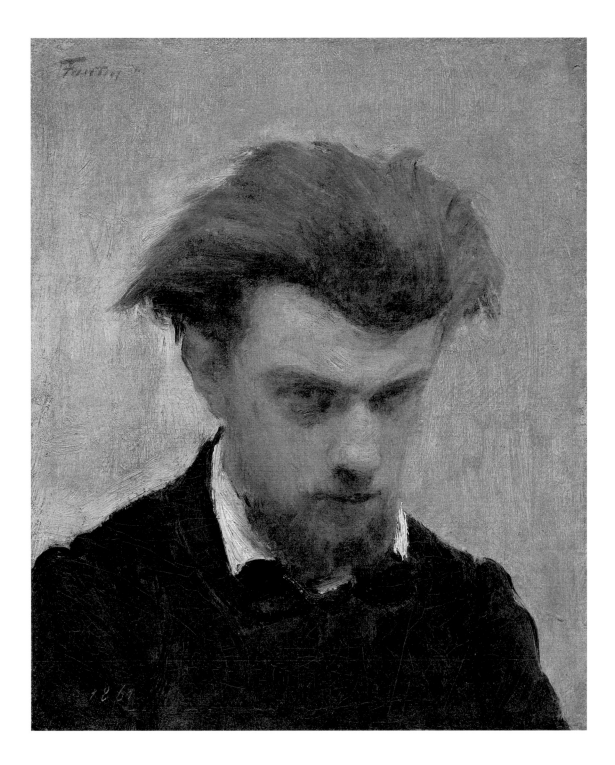

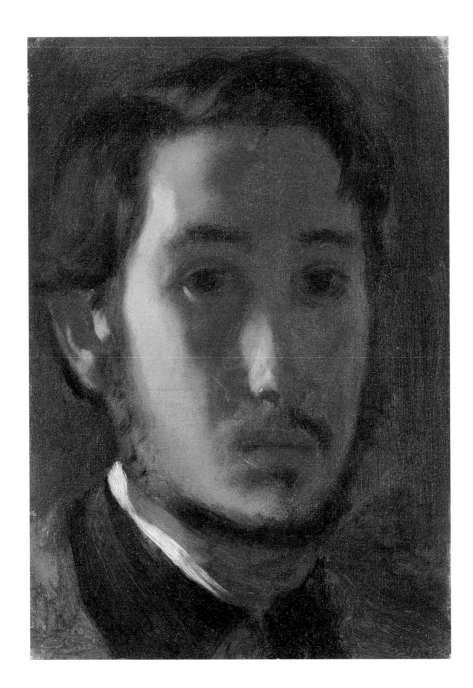

Plate 28
Edgar Degas (French, 1834 – 1917)
Self-Portrait with White Collar, c. 1857
oil on paper on canvas
20.5 × 15 cm (8 ¹⁄₁₆ × 5 ⁷⁄₈ in.)
Collection of Mr. and Mrs. Paul Mellon

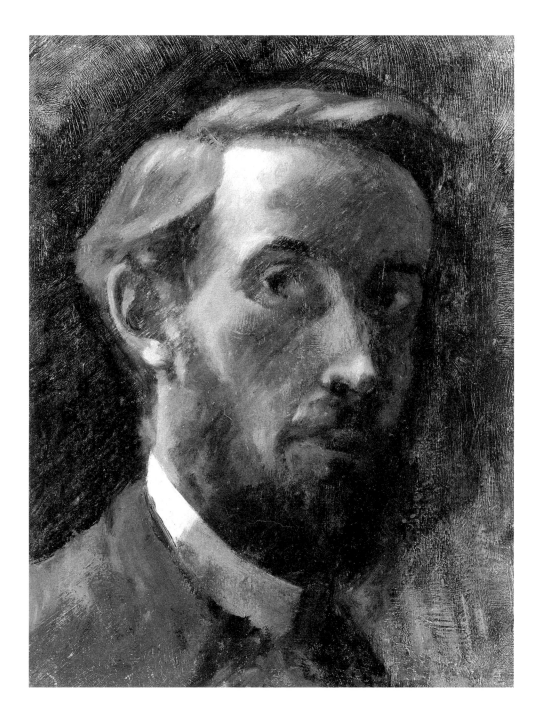

Plate 29
Édouard Vuillard (French, 1868 – 1940)
Self-Portrait, Aged 21, 1889
oil on canvas
22.2 × 17.4 cm (8 ¾ × 6 ⅞ in.)
Collection of Mr. and Mrs. Paul Mellon

75

Plate 30
Auguste Renoir (French, 1841 – 1919)
Claude Monet, 1872
oil on canvas
65 × 50 cm (25 ⁹⁄₁₆ × 19 ¹¹⁄₁₆ in.)
Collection of Mr. and Mrs. Paul Mellon

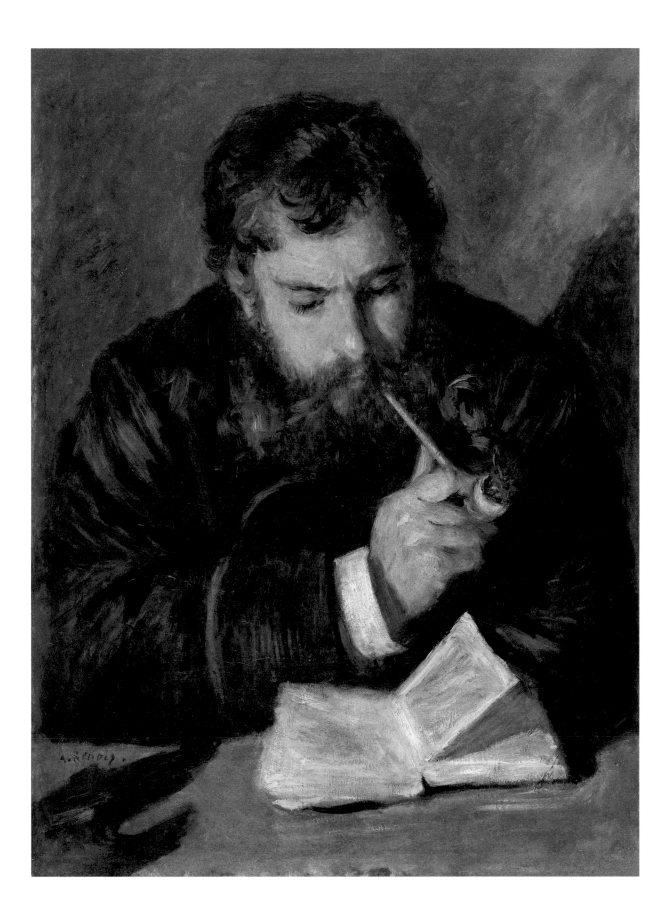

Plate 31
Édouard Manet (French, 1832 – 1883)
George Moore in the Artist's Garden, c. 1879
oil on canvas
54.6 × 45.1 cm (21 ½ × 17 ¾ in.)
Collection of Mr. and Mrs. Paul Mellon

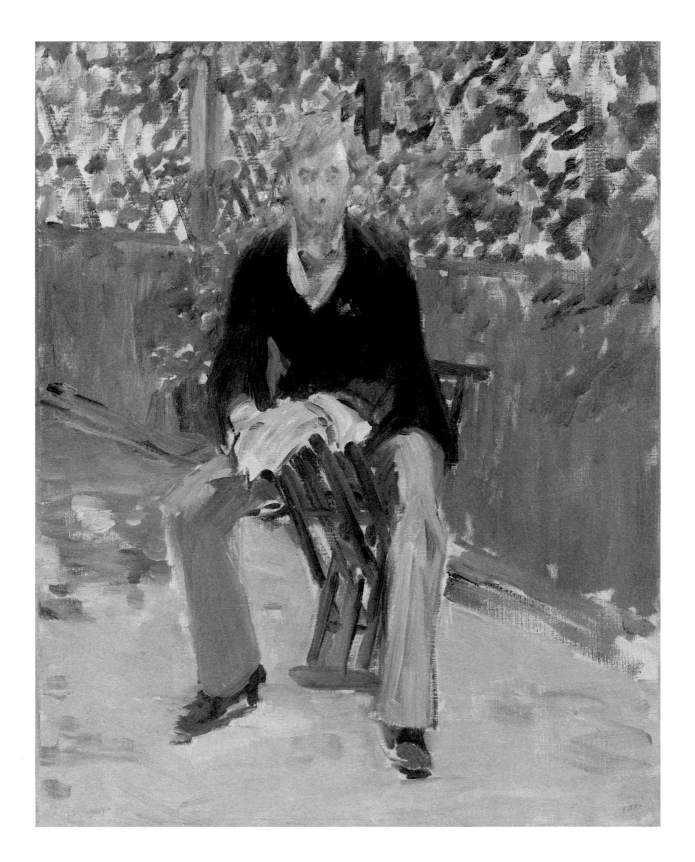

Plate 32
Paul Gauguin (French, 1848 – 1903)
Self-Portrait Dedicated to Carrière, 1888 or 1889
oil on canvas
46.5 × 38.6 cm (18 5/16 × 15 3/16 in.)
Collection of Mr. and Mrs. Paul Mellon

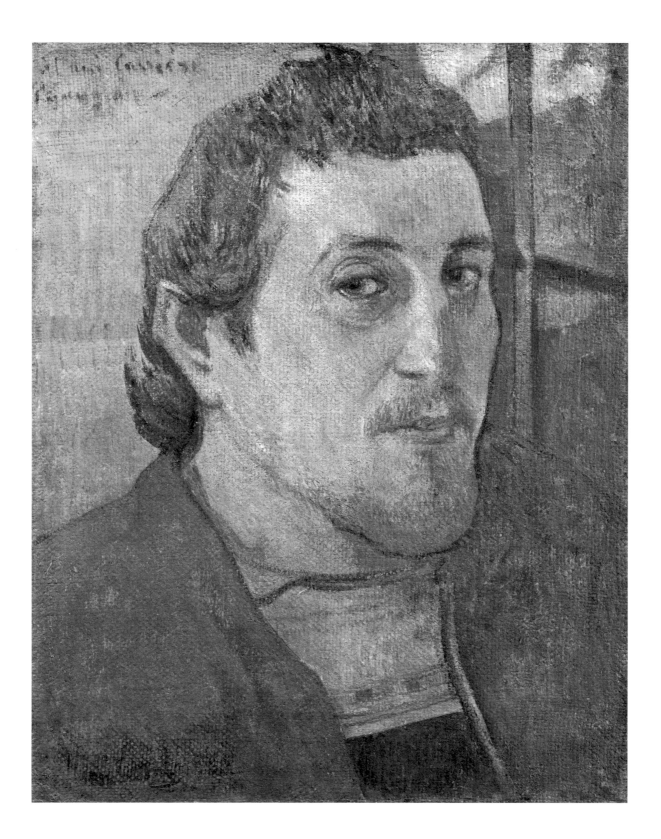

Friends and Models

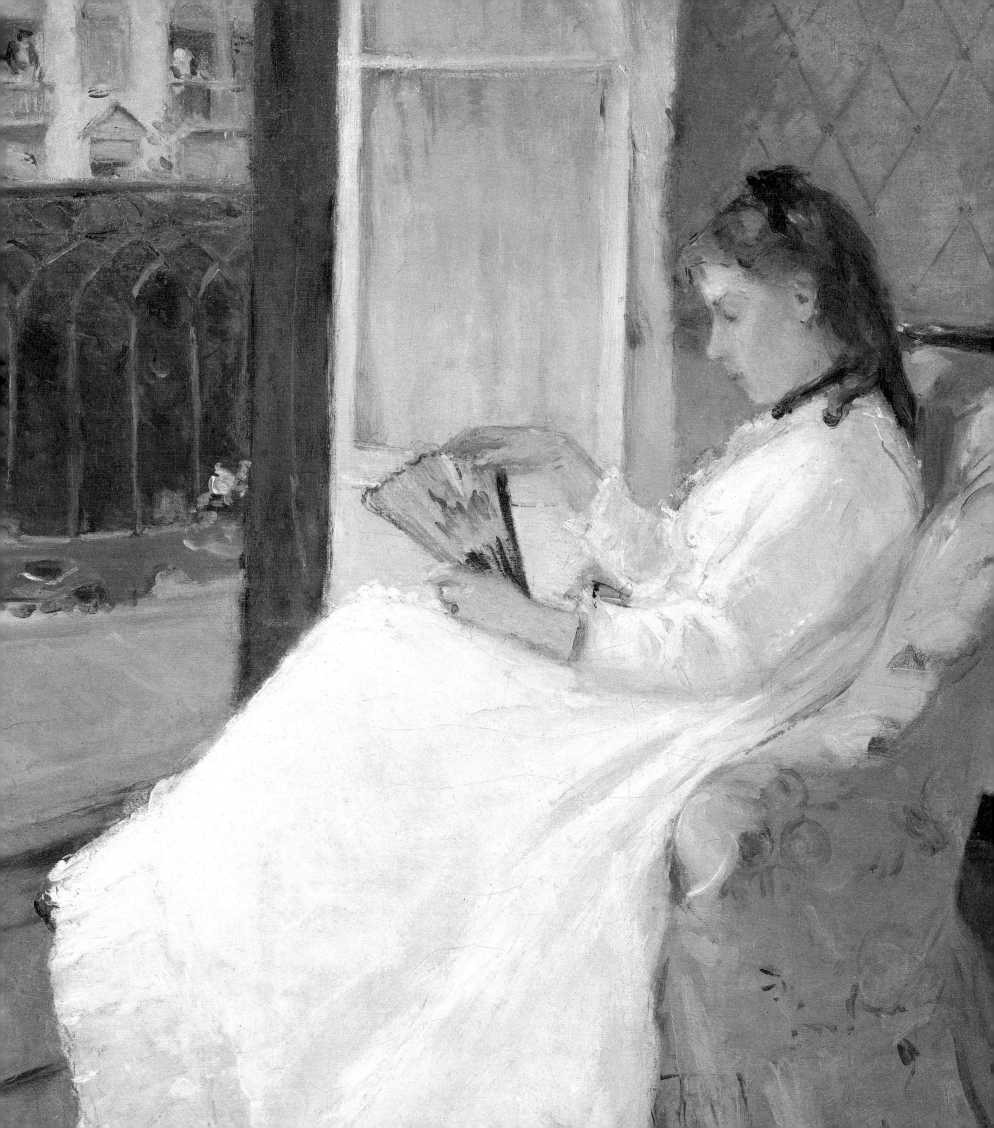

overleaf Berthe Morisot (pl. 34)

Plate 33
Jean-Baptiste-Camille Corot (French, 1796 – 1875)
The Artist's Studio, c. 1868
oil on wood
61.8 × 40 cm (24 5⁄16 × 15 ¾ in.)
Widener Collection

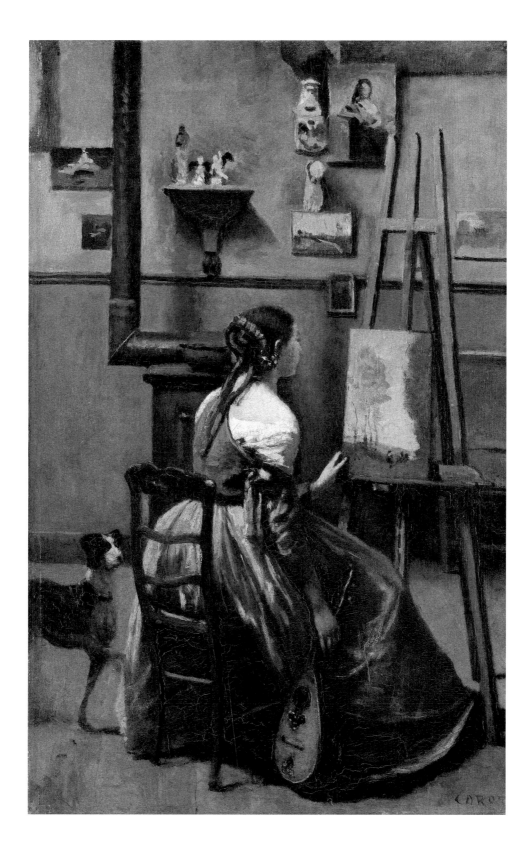

Plate 34
Berthe Morisot (French, 1841–1895)
The Artist's Sister at a Window, 1869
oil on canvas
54.8 × 46.3 cm (21 9/16 × 18 1/4 in.)
Ailsa Mellon Bruce Collection

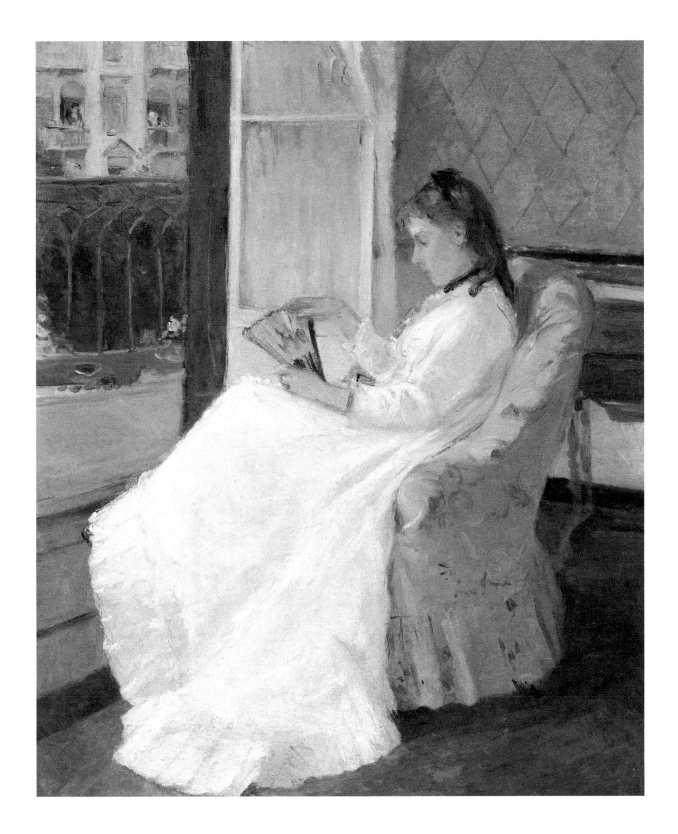

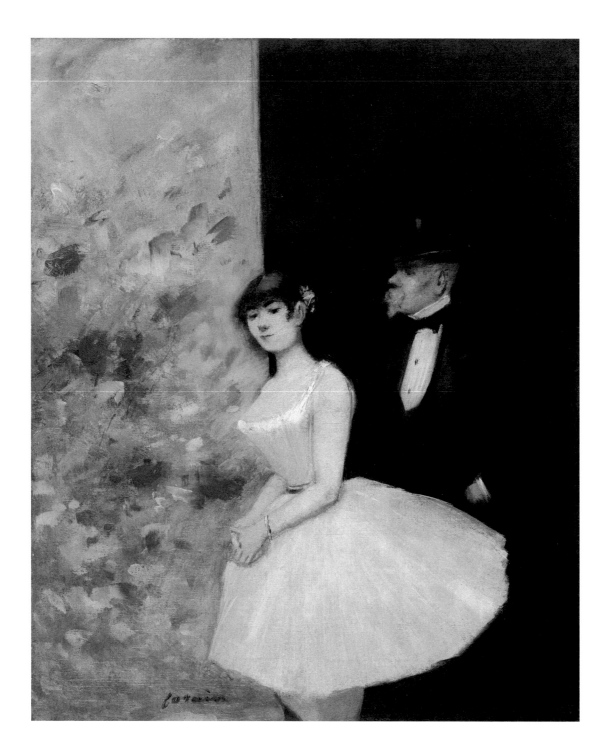

Plate 35
Jean-Louis Forain (French, 1852 – 1931)
Behind the Scenes, c. 1880
oil on canvas
46.4 × 38.4 cm (18 ¼ × 15 ⅛ in.)
Rosenwald Collection

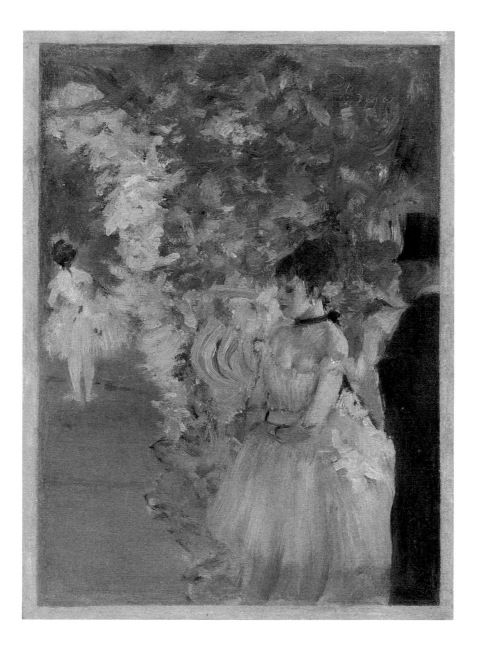

Plate 36
Edgar Degas (French, 1834 – 1917)
Dancers Backstage, 1876/1883
oil on canvas
24.2 × 18.8 cm (9 ½ × 7 ⅜ in.)
89 Ailsa Mellon Bruce Collection

Plate 37
Auguste Renoir (French, 1841–1919)
Madame Henriot, c. 1876
oil on canvas
65.8 × 49.5 cm (25⅞ × 19½ in.)
Gift of the Adele R. Levy Fund, Inc.

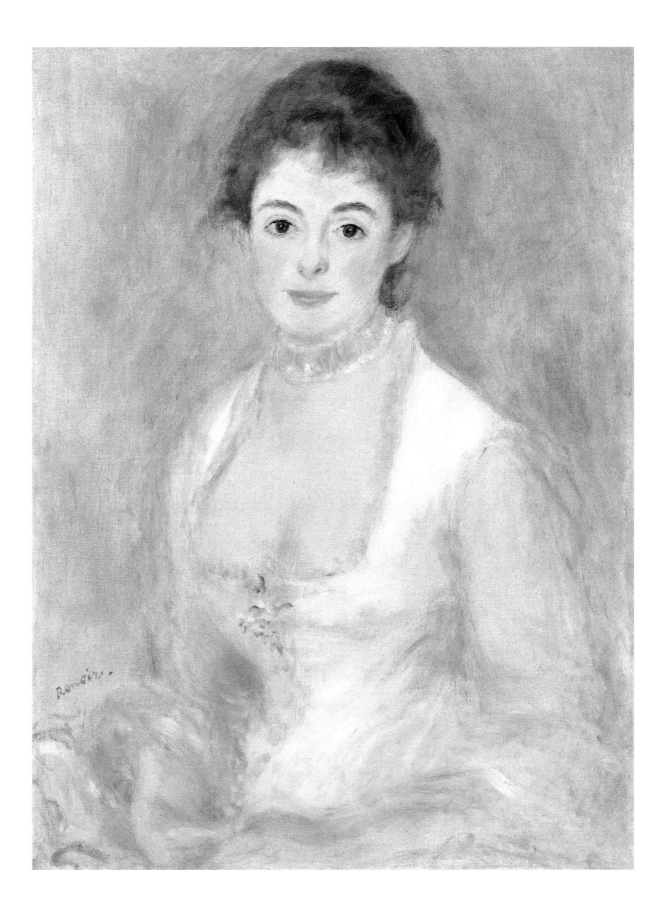

Plate 38
Auguste Renoir (French, 1841 – 1919)
Head of a Young Girl, c. 1890
oil on canvas
42.6 × 33.3 cm (16 ¾ × 13 ⅛ in.)
Gift of Vladimir Horowitz

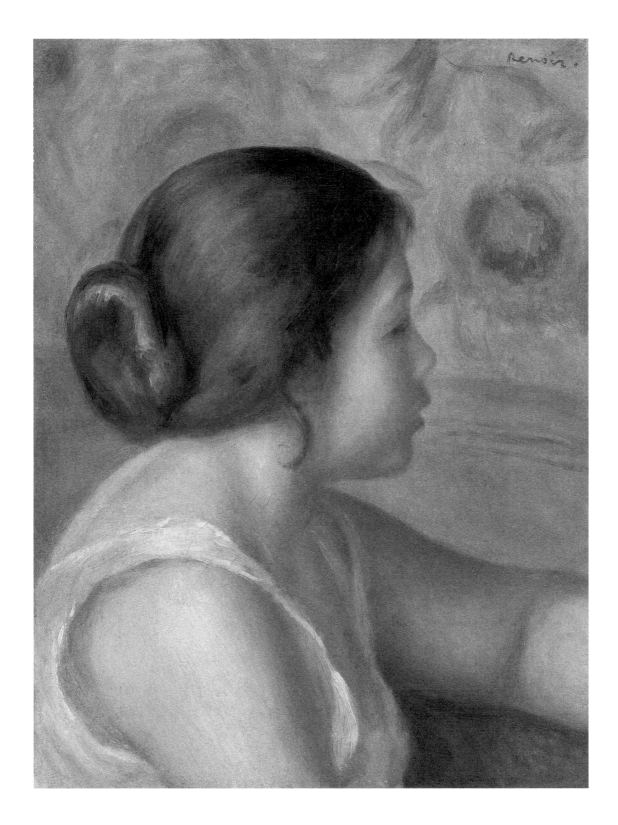

Plate 39
Auguste Renoir (French, 1841–1919)
Madame Monet and Her Son, 1874
oil on canvas
50.4 × 68 cm (19 ¹³⁄₁₆ × 26 ¾ in.)
Ailsa Mellon Bruce Collection

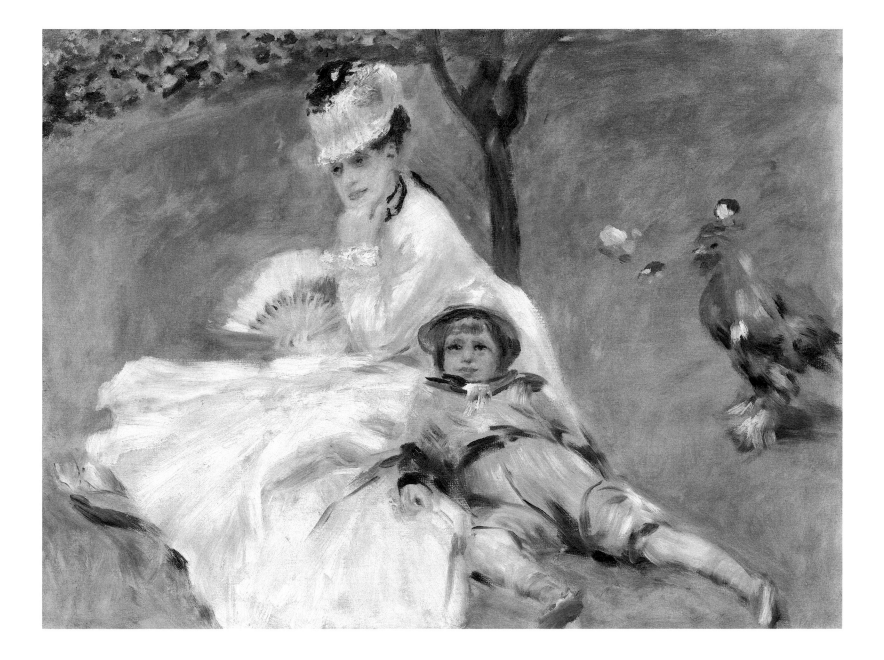

Plate 40
Auguste Renoir (French, 1841 – 1919)
Woman with a Cat, c. 1875
oil on canvas
56 × 46.4 cm (22 ¹⁄₁₆ × 18 ¼ in.)
Gift of Mr. and Mrs. Benjamin E. Levy

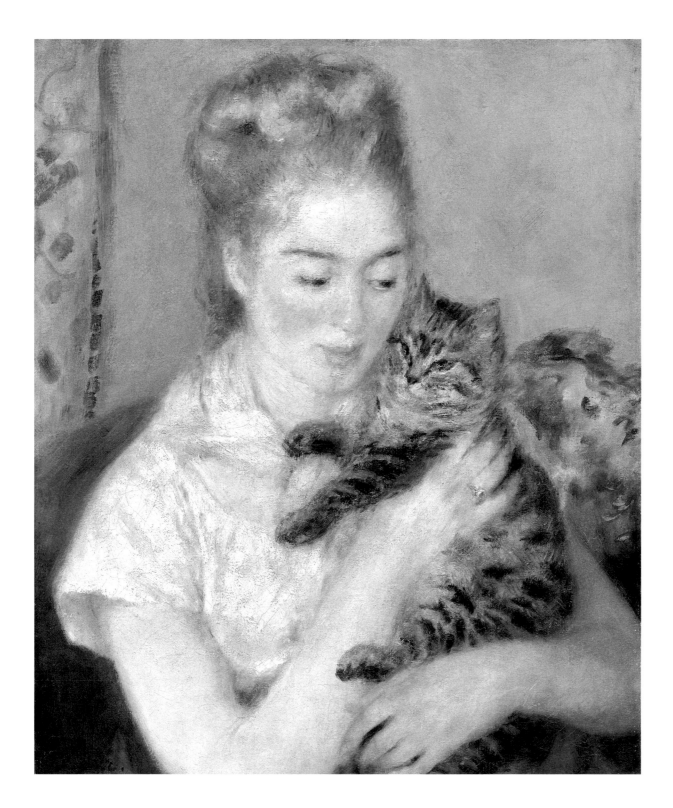

Plate 41
Auguste Renoir (French, 1841–1919)
Young Woman Braiding Her Hair, 1876
oil on canvas
55.5 × 46 cm (21 ⅞ × 18 ⅛ in.)
Ailsa Mellon Bruce Collection

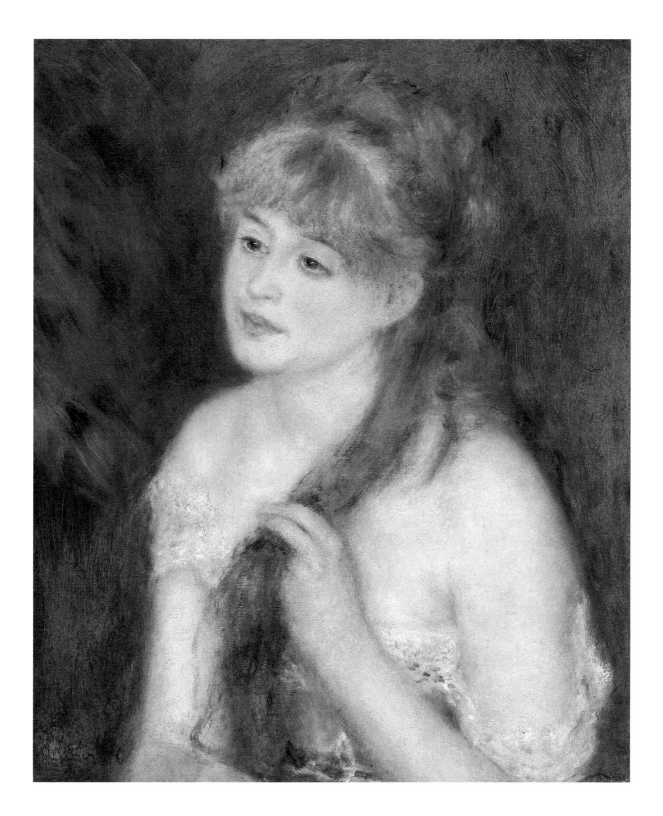

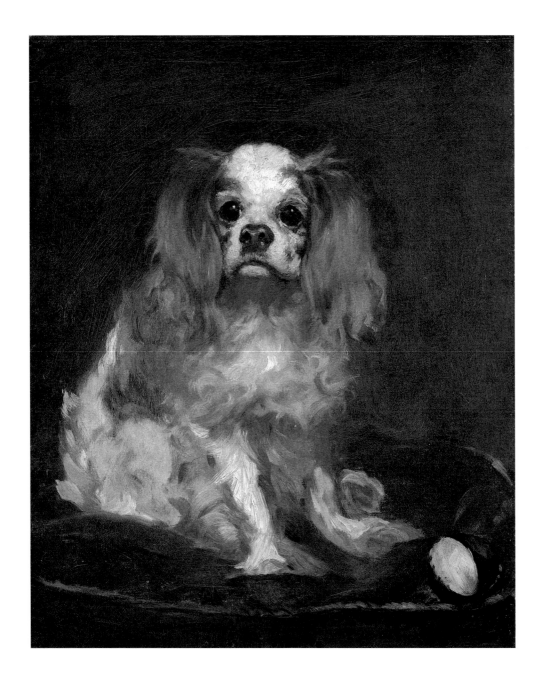

Plate 42
Édouard Manet (French, 1832 – 1883)
A King Charles Spaniel, c. 1866
oil on linen
46 × 38 cm (18 ⅛ × 14 ¹⁵⁄₁₆ in.)
Ailsa Mellon Bruce Collection

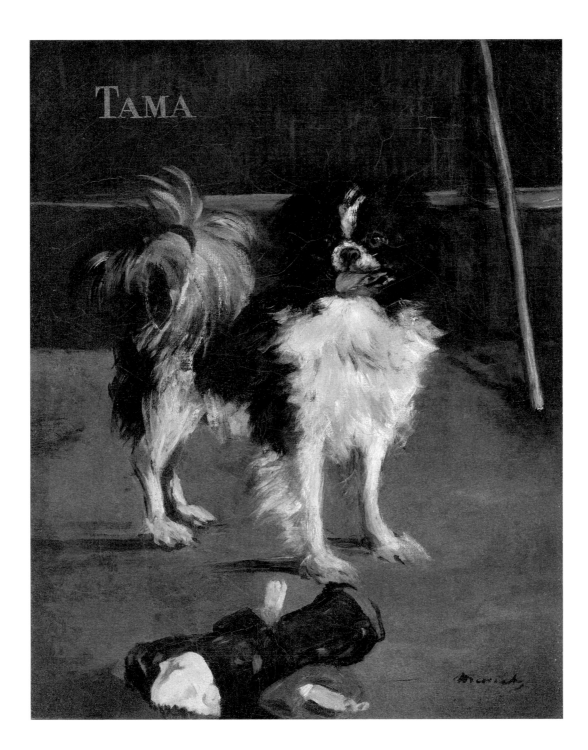

Plate 43
Édouard Manet (French, 1832 – 1883)
Tama, the Japanese Dog, c. 1875
oil on canvas
61 × 50 cm (24 × 19 ¹¹⁄₁₆ in.)
Collection of Mr. and Mrs. Paul Mellon

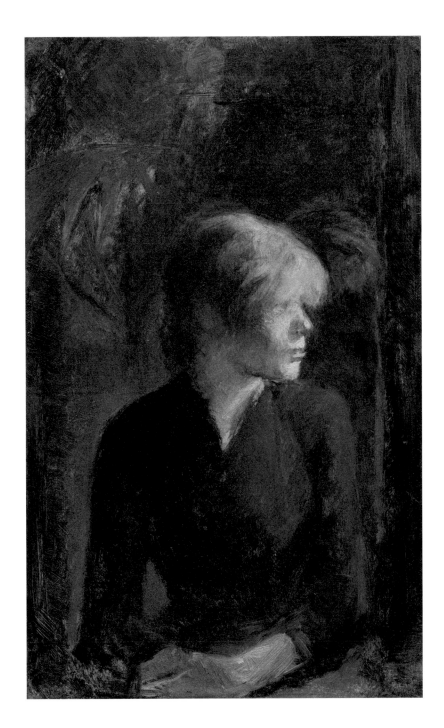

Still Lifes

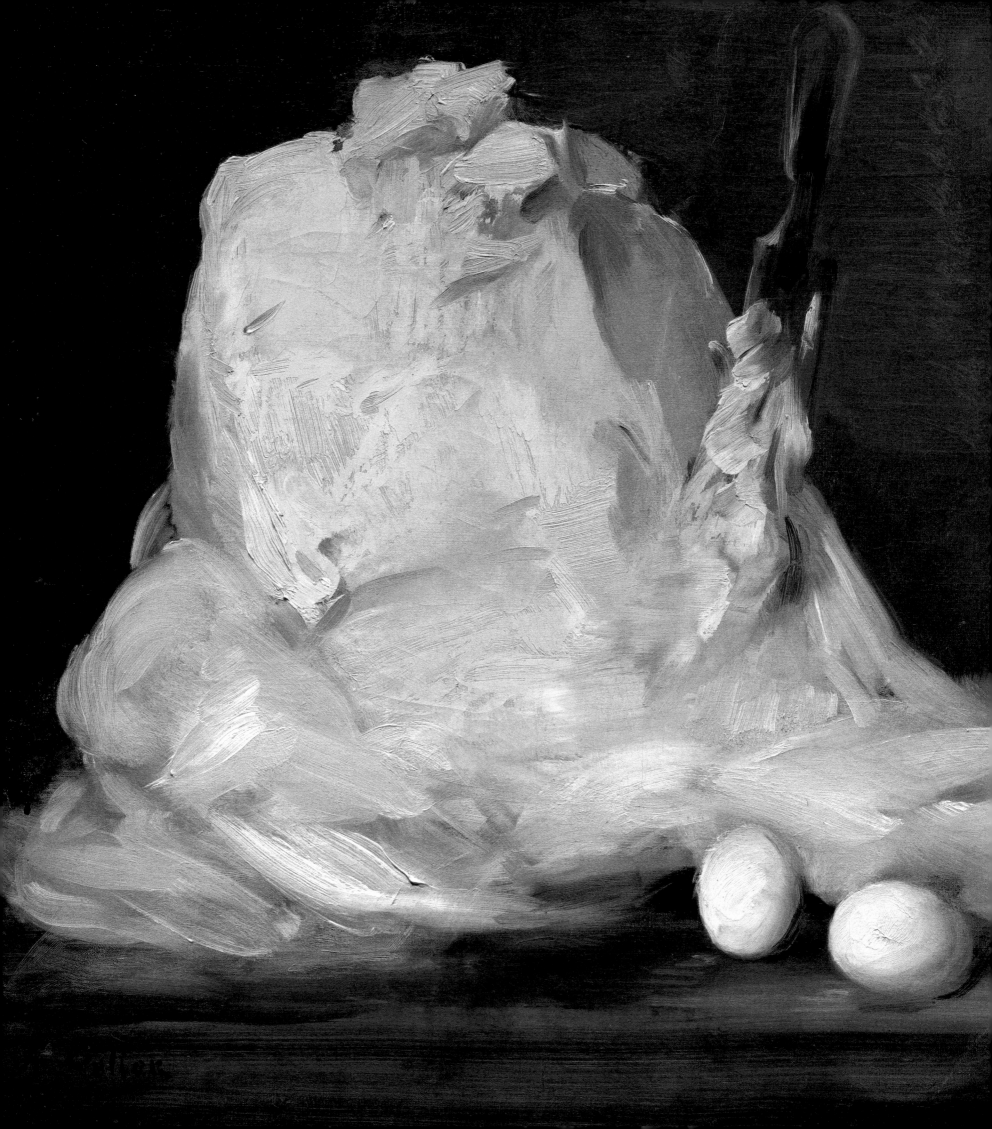

overleaf Antoine Vollon (pl. 46)

Plate 45
Édouard Manet (French, 1832 – 1883)
Oysters, 1862
oil on canvas
39.2 × 46.8 cm (15 ⁷⁄₁₆ × 18 ⁷⁄₁₆ in.)
Gift of the Adele R. Levy Fund, Inc.

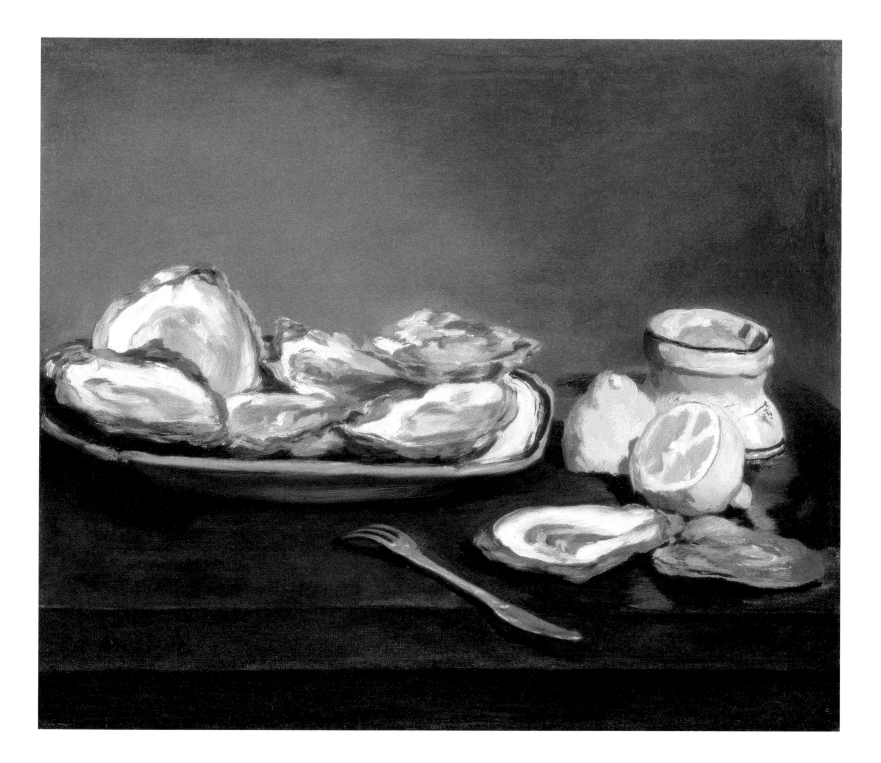

Plate 46
Antoine Vollon (French, 1833 – 1900)
Mound of Butter, 1875/1885
oil on canvas
50.2 × 61 cm (19 ¾ × 24 in.)
Chester Dale Fund

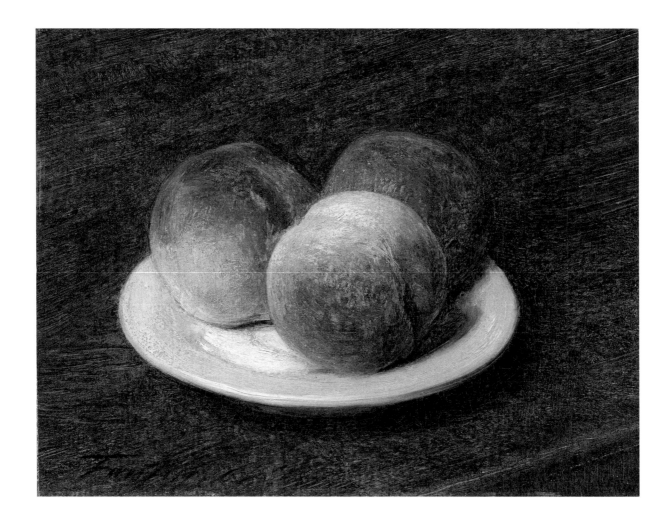

Plate 47
Henri Fantin-Latour (French, 1836–1904)
Three Peaches on a Plate, 1868
oil on paper on canvas
19.7 × 25.7 cm (7 ¾ × 10 ⅛ in.)

Collection of Mr. and Mrs. Paul Mellon

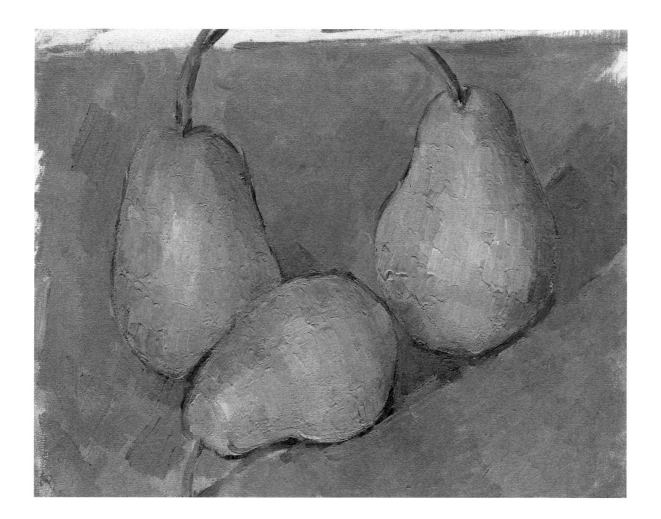

Plate 48
Paul Cézanne (French, 1839 – 1906)
Three Pears, 1878/1879
oil on canvas
20 × 25.7 cm (7 ⅞ × 10 ⅛ in.)
Collection of Mr. and Mrs. Paul Mellon

Plate 49
Henri Fantin-Latour (French, 1836 – 1904)
Still Life with Grapes and a Carnation, c. 1880
oil on canvas
30.5 × 47 cm (12 × 18 ½ in.)
Collection of Mr. and Mrs. Paul Mellon

Plate 50
Auguste Renoir (French, 1841 – 1919)
Peaches on a Plate, 1902/1905
oil on canvas
22.2 × 35.6 cm (8 ¾ × 14 in.)
Ailsa Mellon Bruce Collection

Plate 51
Paul Cézanne (French, 1839 – 1906)
Still Life with Milk Jug and Fruit, c. 1900
oil on canvas
45.8 × 54.9 cm (18 ¹⁄₁₆ × 21 ⅝ in.)
Gift of the W. Averell Harriman Foundation
in memory of Marie N. Harriman

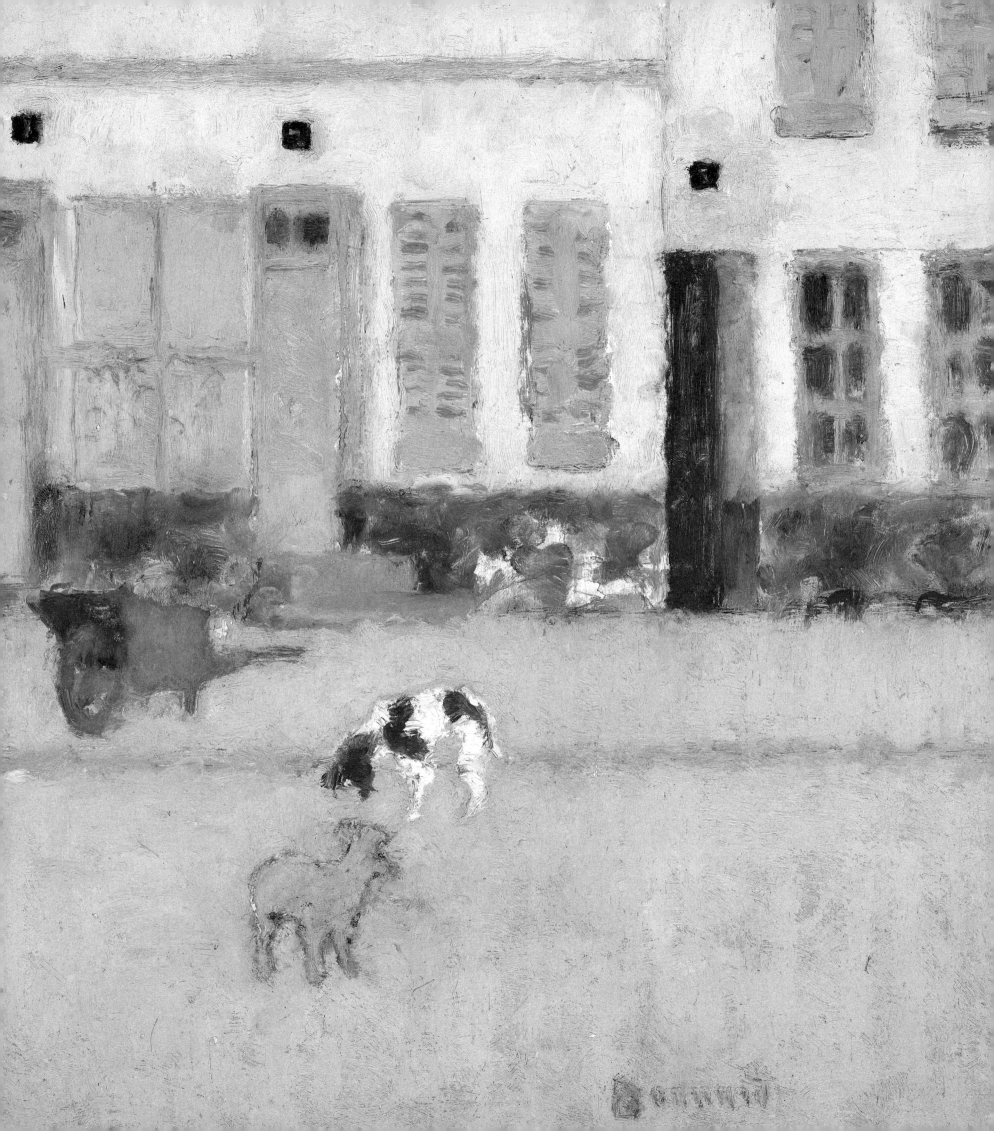

overleaf Pierre Bonnard (pl. 55)

Plate 52
Pierre Bonnard (French, 1867 – 1947)
Red Plums, 1892
oil on canvas
24.8 × 33.7 cm (9 ¾ × 13 ¼ in.)
Collection of Mr. and Mrs. Paul Mellon

Plate 53
Pierre Bonnard (French, 1867 – 1947)
The Cab Horse, c. 1895
oil on wood
29.7 × 40 cm (11 ¹¹⁄₁₆ × 15 ¾ in.)
Ailsa Mellon Bruce Collection

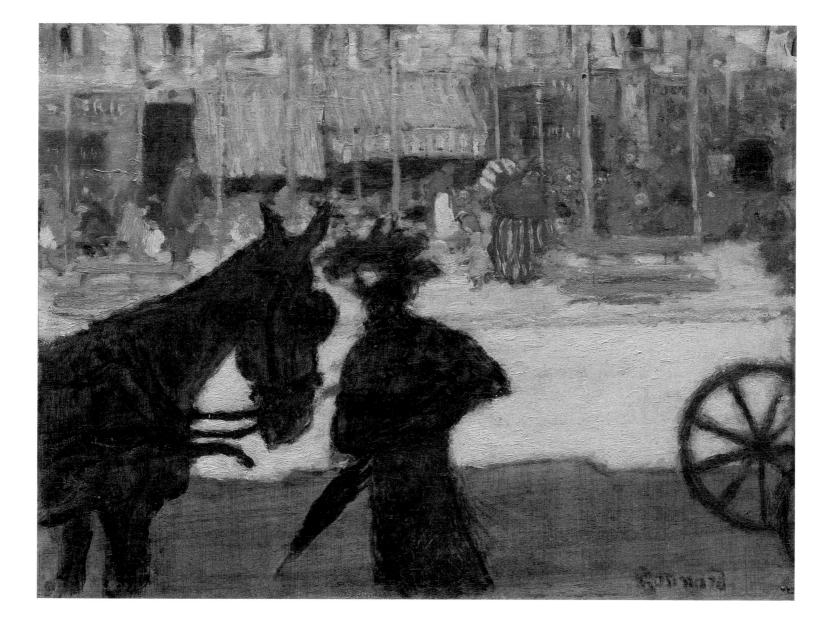

Plate 54
Pierre Bonnard (French, 1867 – 1947)
Paris, Rue de Parme on Bastille Day, 1890
oil on canvas
79.2 × 40.3 cm (31 ³⁄₁₆ × 15 ⅞ in.)
Collection of Mr. and Mrs. Paul Mellon

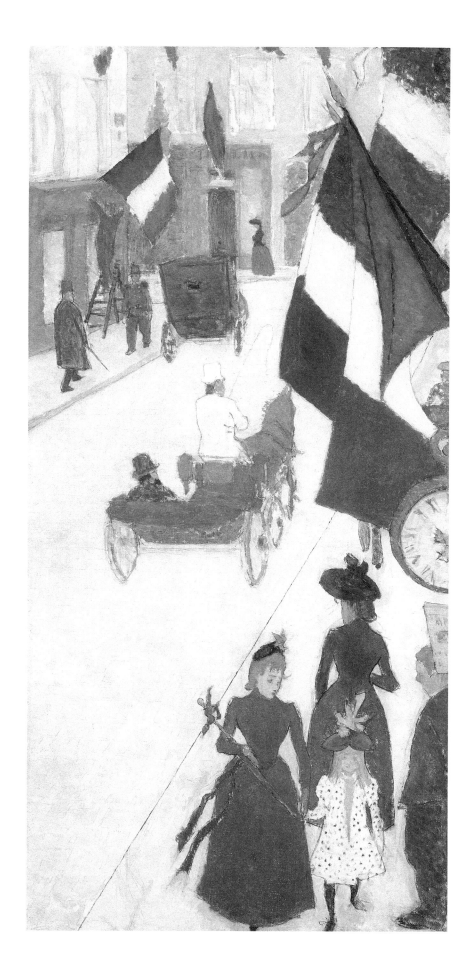

Plate 55
Pierre Bonnard (French, 1867–1947)
Two Dogs in a Deserted Street, c. 1894
oil on wood
35.1 × 27 cm (13 ¹³⁄₁₆ × 10 ⅝ in.)
Ailsa Mellon Bruce Collection

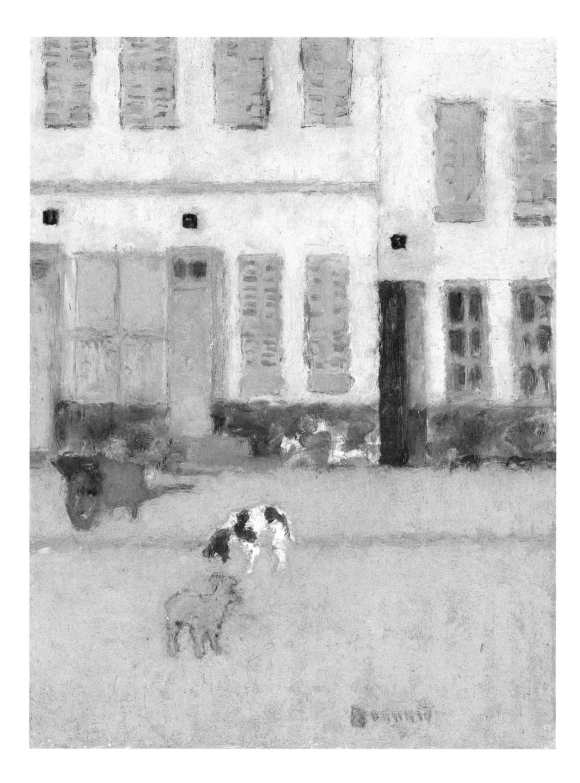

Plate 56
Édouard Vuillard (French, 1868 – 1940)
Landscape of the Île-de-France, c. 1894
oil on cardboard
19.7 × 25.3 cm (7 ¾ × 9 ¹⁵⁄₁₆ in.)
Collection of Mr. and Mrs. Paul Mellon

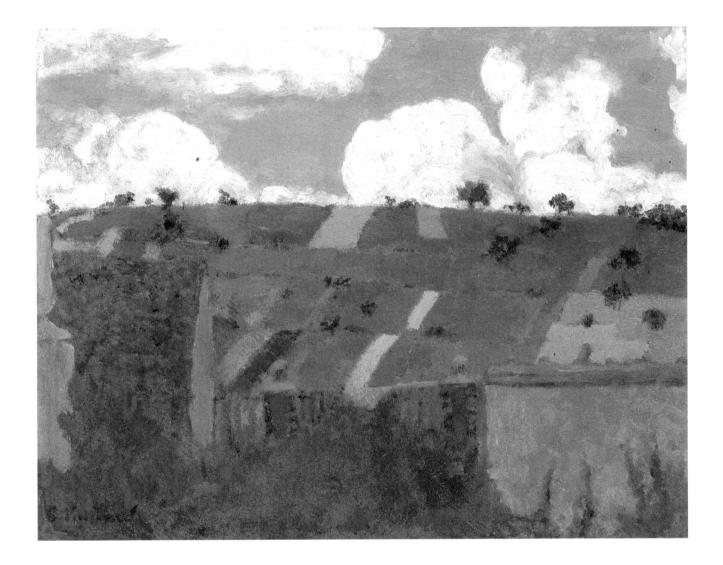

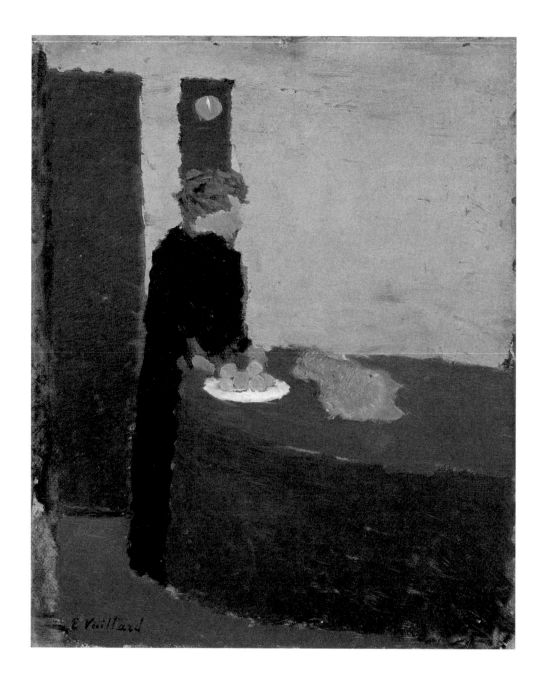

Plate 57
Édouard Vuillard (French, 1868 – 1940)
Woman in Black, c. 1891
oil on cardboard
26.8 × 21.9 cm (10 9/16 × 8 5/8 in.)
Ailsa Mellon Bruce Collection

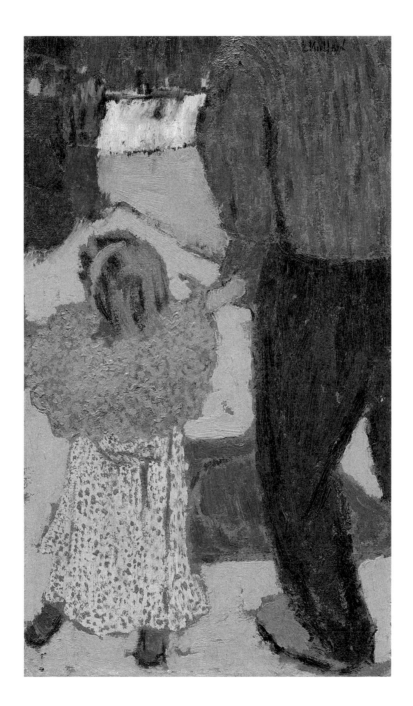

Plate 58
Édouard Vuillard (French, 1868 – 1940)
Child Wearing a Red Scarf, c. 1891
oil on cardboard
29.2 × 17.5 cm (11 ½ × 6 ⅞ in.)
Ailsa Mellon Bruce Collection

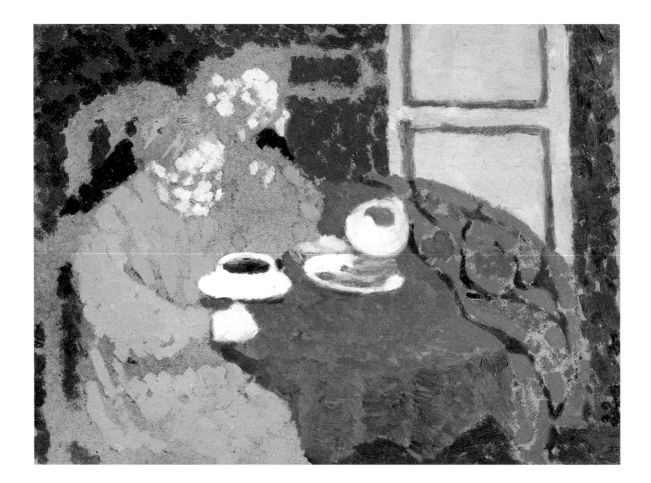

Plate 59
Édouard Vuillard (French, 1868 – 1940)
Two Women Drinking Coffee, c. 1893
oil on cardboard
21.5 × 28.8 cm (8 ⁷⁄₁₆ × 11 ⁵⁄₁₆ in.)
Ailsa Mellon Bruce Collection

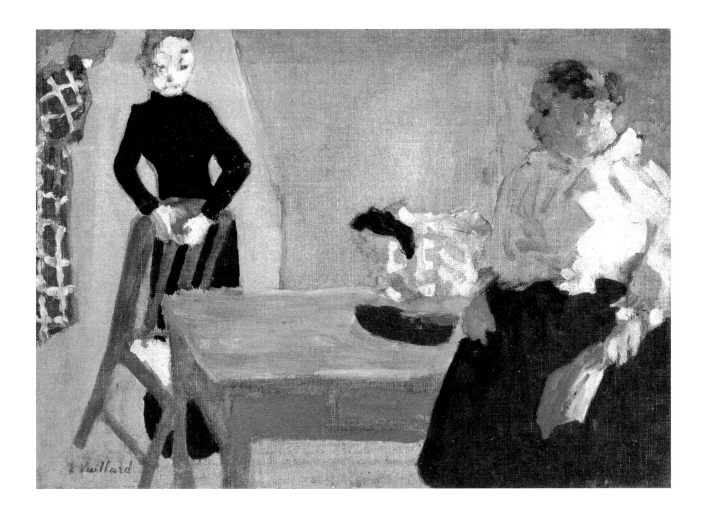

Plate 60
Édouard Vuillard (French, 1868 – 1940)
The Conversation, 1891
oil on canvas
23.8 × 33.4 cm (9 ⅜ × 13 ⅛ in.)
Ailsa Mellon Bruce Collection

Plate 61
Édouard Vuillard (French, 1868 – 1940)
The Yellow Curtain, c. 1893
oil on canvas
34.7 × 38.7 cm (13 ¹¹⁄₁₆ × 15 ¼ in.)
Ailsa Mellon Bruce Collection

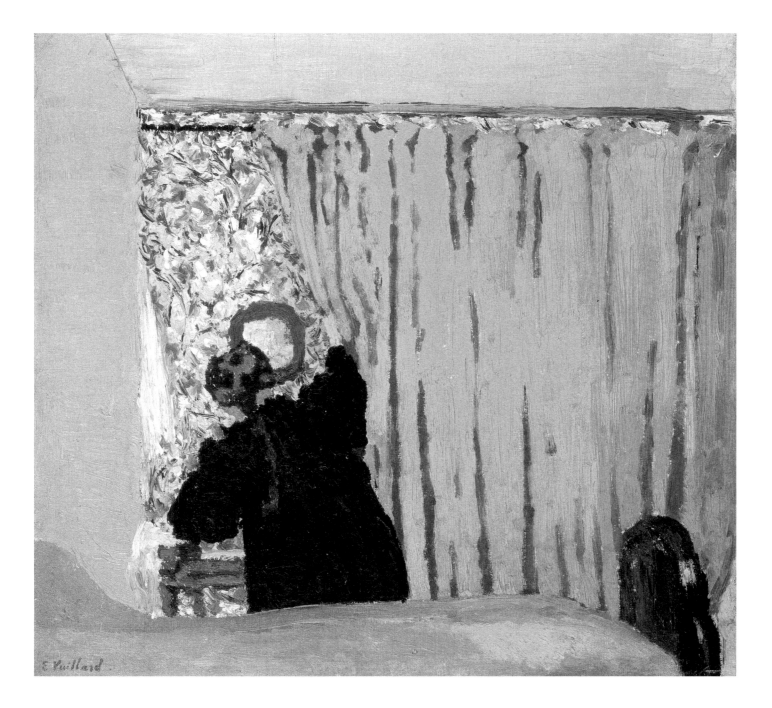

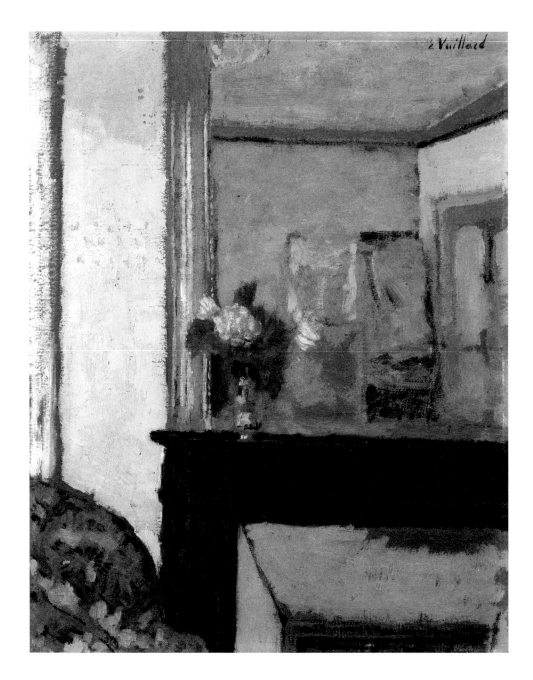

Plate 62
Édouard Vuillard (French, 1868 – 1940)
Vase of Flowers on a Mantelpiece, c. 1900
oil on cardboard
36.2 × 29.5 cm (14 ¼ × 11 ⅝ in.)
Ailsa Mellon Bruce Collection

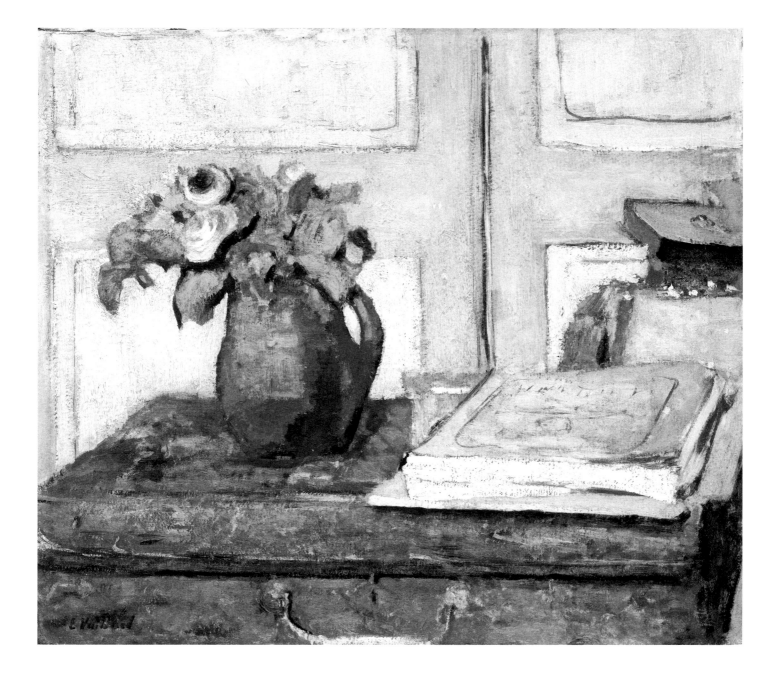

Plate 63
Édouard Vuillard (French, 1868–1940)
The Artist's Paint Box and Moss Roses, 1898
oil on cardboard
36.1 × 42.9 cm (14 ³⁄₁₆ × 16 ⁷⁄₈ in.)
135 Ailsa Mellon Bruce Collection

Plate 64
Pierre Bonnard (French, 1867 – 1947)
The Artist's Studio, 1900
oil on wood
61.5 × 74.8 cm (24 ³⁄₁₆ × 29 ⁷⁄₁₆ in.)
Collection of Mr. and Mrs. Paul Mellon

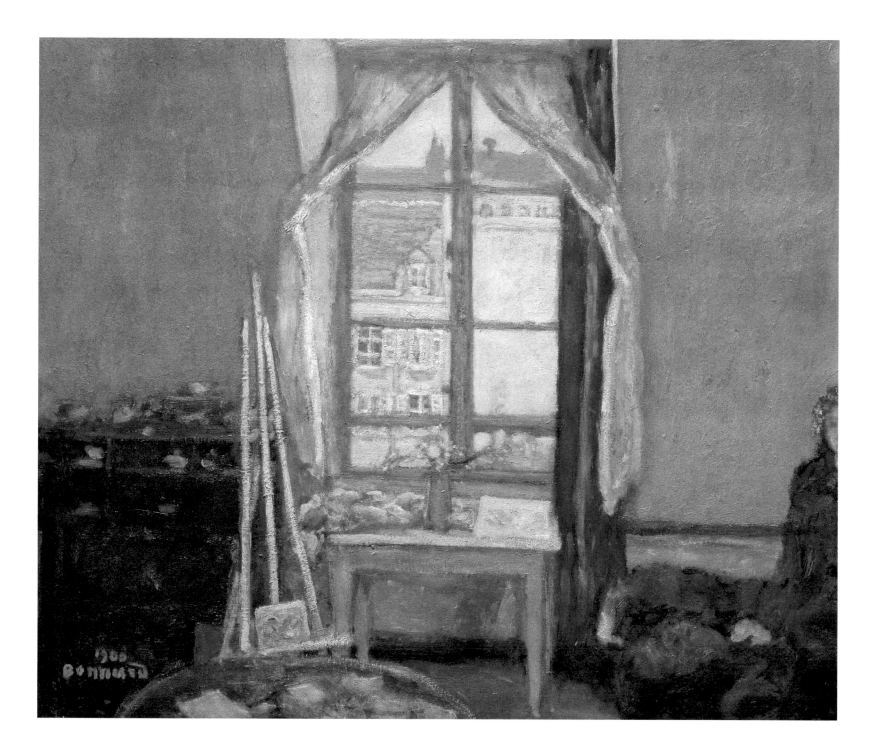

Plate 65
Pierre Bonnard (French, 1867–1947)
The Green Table, c. 1910
oil on canvas
51 × 65 cm (20 1/16 × 25 9/16 in.)
Ailsa Mellon Bruce Collection

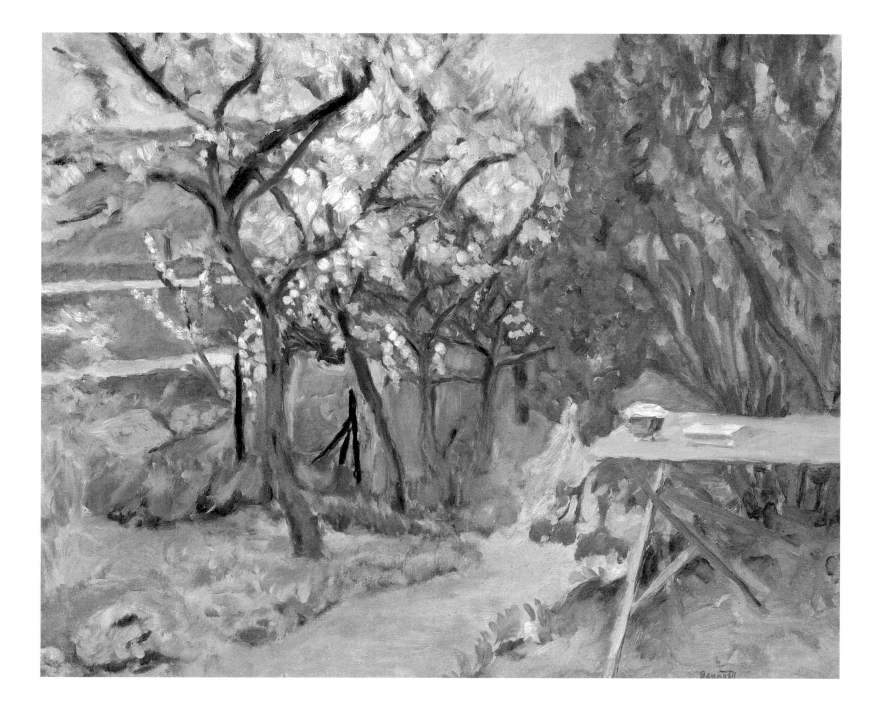

Plate 66
Pierre Bonnard (French, 1867–1947)
Table Set in a Garden, c. 1908
oil on paper on canvas
49.5 × 64.7 cm (19 ½ × 25 ½ in.)
Ailsa Mellon Bruce Collection

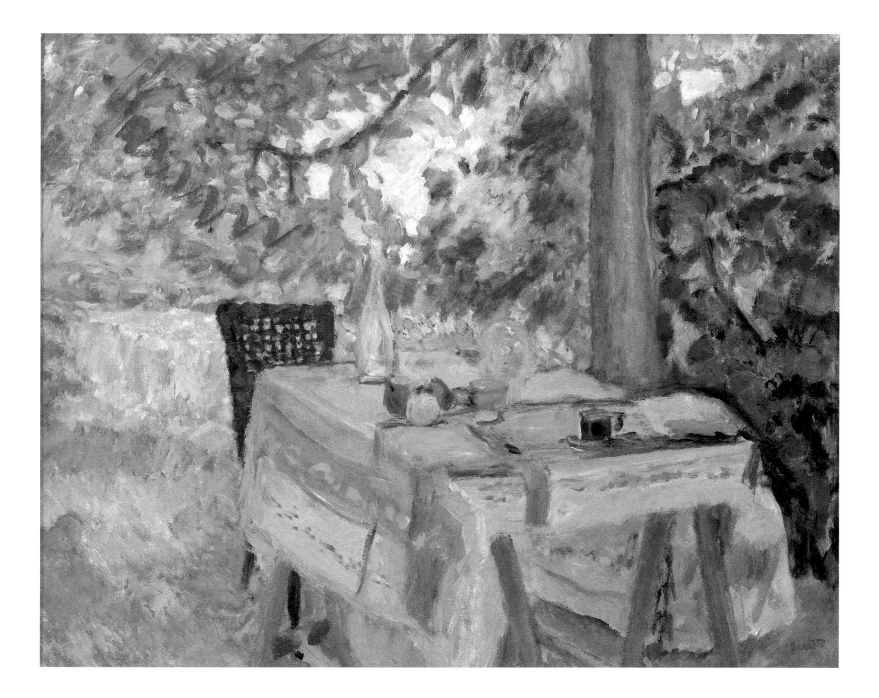

Plate 67
Pierre Bonnard (French, 1867 – 1947)
Bouquet of Flowers, c. 1926
oil on canvas
70.1 × 47.2 cm (27 ⅝ × 18 ⁹⁄₁₆ in.)
Ailsa Mellon Bruce Collection

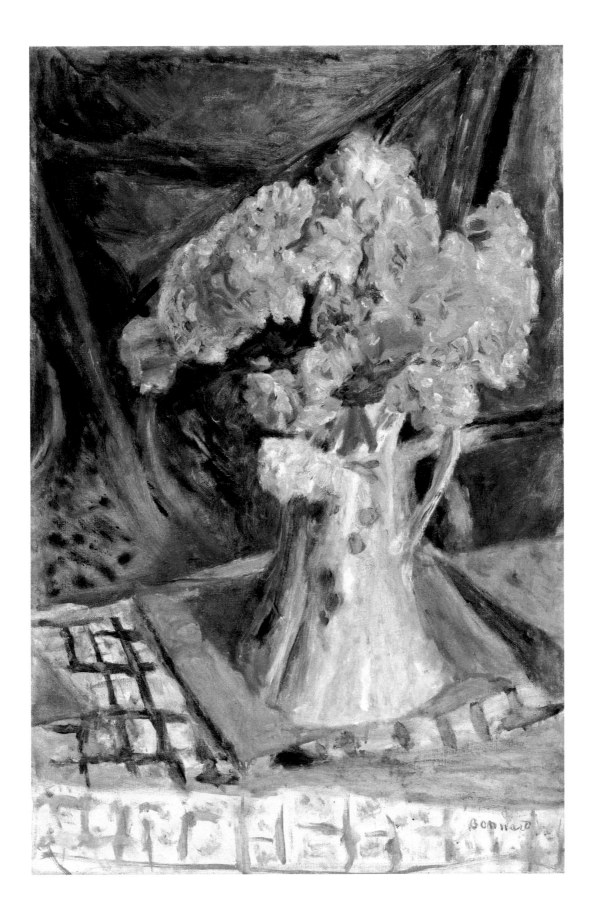

Plate 68
Pierre Bonnard (French, 1867 – 1947)
Stairs in the Artist's Garden, 1942/1944
oil on canvas
60 × 73 cm (23 ⅝ × 28 ¾ in.)
Ailsa Mellon Bruce Collection

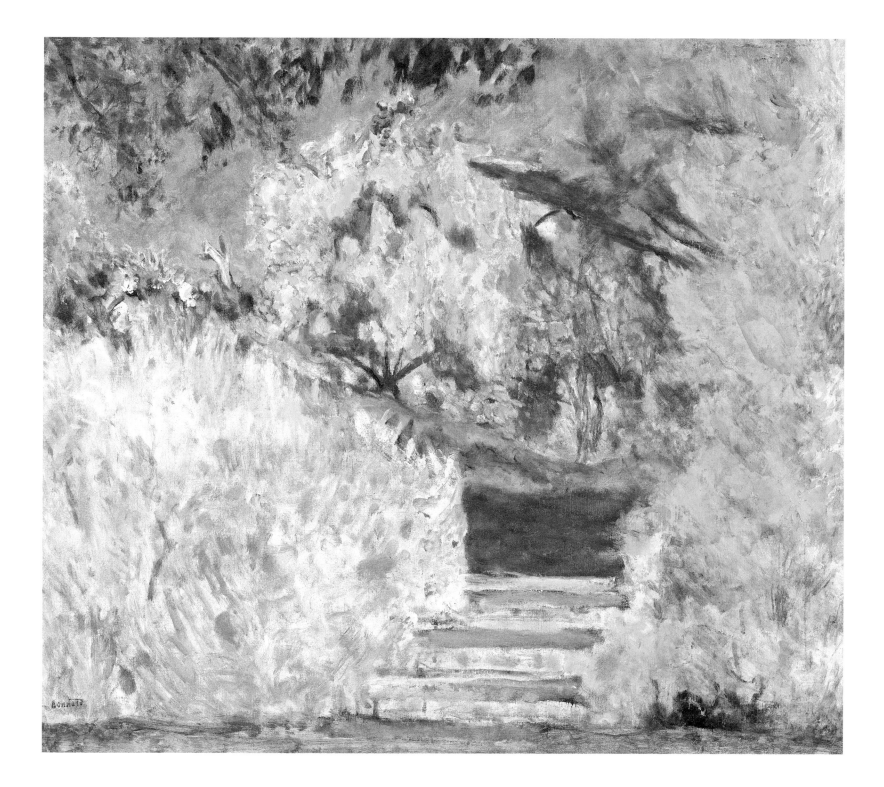

Index of Artists and Titles

Pierre Bonnard

Red Plums (pl. 52)
The Cab Horse (pl. 53)
Paris, Rue de Parme on Bastille Day (pl. 54)
Two Dogs in a Deserted Street (pl. 55)
The Artist's Studio (pl. 64)
The Green Table (pl. 65)
Table Set in a Garden (pl. 66)
Bouquet of Flowers (pl. 67)
Stairs in the Artist's Garden (pl. 68)

Eugène Boudin

Festival in the Harbor of Honfleur (pl. 8)
Beach at Trouville (pl. 9)
Beach Scene at Trouville (pl. 10)
Concert at the Casino of Deauville (pl. 11)
Coast of Brittany (pl. 12)
Washerwoman near Trouville (pl. 13)
Women on the Beach at Berck (p. 14)
Yacht Basin at Trouville-Deauville (pl. 15)

Paul Cézanne

The Battle of Love (pl. 21)
Three Pears (pl. 48)
Still Life with Milk Jug and Fruit (pl. 51)

Jean-Baptiste-Camille Corot

The Artist's Studio (pl. 33)

Edgar Degas

Horses in a Meadow (pl. 18)
The Races (p. 19)
Self-Portrait with White Collar (pl. 28)
Dancers Backstage (pl. 36)

Henri Fantin-Latour

Self-Portrait (pl. 27)
Three Peaches on a Plate (pl. 47)
Still Life with Grapes and a Carnation (pl. 49)

Jean-Louis Forain

Behind the Scenes (pl. 35)

Paul Gauguin

Self-Portrait Dedicated to Carrière (pl. 32)

Vincent van Gogh

Flower Beds in Holland (pl. 22)

Johan Barthold Jongkind

The Towpath (pl. 1)

Édouard Manet

At the Races (pl. 20)
George Moore in the Artist's Garden (pl. 31)
A King Charles Spaniel (pl. 42)
Tama, the Japanese Dog (pl. 43)
Oysters (pl. 45)

Claude Monet

Argenteuil (pl. 2)

Berthe Morisot

The Artist's Sister at a Window (pl. 34)

Camille Pissarro

The Fence (pl. 3)
Orchard in Bloom, Louveciennes (pl. 4)

Odilon Redon

Breton Village (pl. 23)
Village by the Sea in Brittany (pl. 24)

Auguste Renoir

Picking Flowers (pl. 16)
The Vintagers (pl. 17)
Claude Monet (pl. 30)
Madame Henriot (pl. 37)
Head of a Young Girl (pl. 38)
Madame Monet and Her Son (pl. 39)
Woman with a Cat (pl. 40)
Young Woman Braiding Her Hair (pl. 41)
Peaches on a Plate (pl. 50)

Georges Seurat

Study for "La Grande Jatte" (pl. 25)
Seascape (Gravelines) (pl. 26)

Alfred Sisley

Boulevard Héloïse, Argenteuil (pl. 5)
Flood at Port-Marly (pl. 6)
Meadow (pl. 7)

Henri de Toulouse-Lautrec

Carmen Gaudin (pl. 44)

Antoine Vollon

Mound of Butter (pl. 46)

Édouard Vuillard

Self-Portrait, Aged 21 (pl. 29)
Landscape of the Île-de-France (pl. 56)
Woman in Black (pl. 57)
Child Wearing a Red Scarf (pl. 58)
Two Women Drinking Coffee (pl. 59)
The Conversation (pl. 60)
The Yellow Curtain (pl. 61)
Vase of Flowers on a Mantelpiece (pl. 62)
The Artist's Paint Box and Moss Roses (pl. 63)